One

THE ORIGIN OF A LEGEND

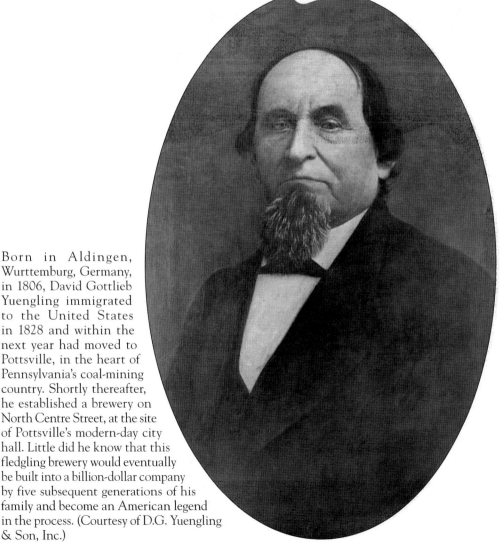

Born in Aldingen, Wurttemburg, Germany, in 1806, David Gottlieb Yuengling immigrated to the United States in 1828 and within the next year had moved to Pottsville, in the heart of Pennsylvania's coal-mining country. Shortly thereafter, he established a brewery on North Centre Street, at the site of Pottsville's modern-day city hall. Little did he know that this fledgling brewery would eventually be built into a billion-dollar company by five subsequent generations of his family and become an American legend in the process. (Courtesy of D.G. Yuengling & Son, Inc.)

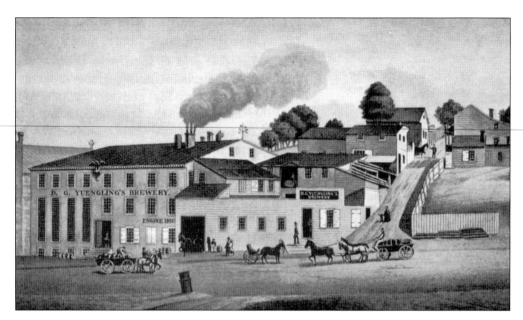

Yuengling's first brewery on North Centre Street was destroyed by fire in 1831, after which he rebuilt the plant at its present location, on the southeast corner of Fifth and Mahantongo Streets. Above is the earliest known drawing of the brewery complex as it appeared in the 1840s. It shows the original brewhouse on the left, at the present site of the bottling building and loading dock. Below is the earliest known advertisement for the new brewery, featuring the same illustration. (Both, courtesy of D.G. Yuengling & Son, Inc.)

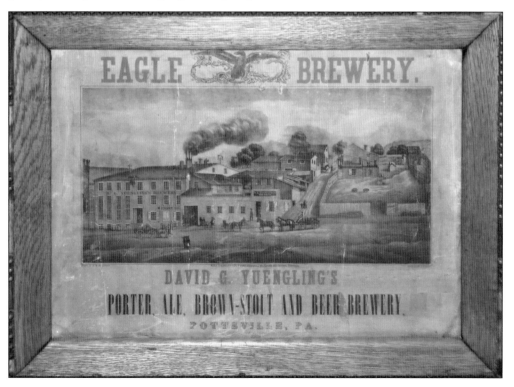

IMAGES
of America

D.G. YUENGLING
& SON, INC.

Robert A. Musson, MD
Foreword by Dick Yuengling

ARCADIA
PUBLISHING

Published by Arcadia Publishing
Charleston, South Carolina

Printed in the United States of America

Library of Congress Control Number: 2013933847

For all general information, please contact Arcadia Publishing:
Telephone 843-853-2070
Fax 843-853-0044
E-mail sales@arcadiapublishing.com
For customer service and orders:
Toll-Free 1-888-313-2665

Visit us on the Internet at www.arcadiapublishing.com

*This book is dedicated to my parents, Irvin and Frances Musson,
who were amazingly willing to allow many of our family vacations to
center around my interests of history and "breweriana" collecting.*

CONTENTS

FOREWORD

As the president of D.G. Yuengling & Son, Inc., I would like to thank you for your interest in our company's history, which is one in the same with our family's history. With the Yuenglings having brewed beer in Pottsville since 1829, we feel that we have something very special here and that our family has a special connection with the city and the rest of eastern Pennsylvania. Having spent much of my life in and around the old brewery at Fifth and Mahantongo Streets, you might think that I would take this place for granted after a while. Nothing could be further from the truth! I appreciate the history and the legacy of this place as much now as I did 50 years ago . . . probably even more now. Certainly our Tampa and Mill Creek plants are larger and more modern, but knowing that my great-great-grandfather brewed beer at this same spot where we brew today is a special feeling that is unique to our family.

As we approach our 185th anniversary in the brewing business, we are excited to see the growth that the company has experienced in the past 30 years. Having gone from sales of less than 150,000 barrels per year in the 1980s to more than 2.5 million barrels per year now, we are able to share the history of our company and our family with more people than ever. Looking at this rapid growth in recent years, it is very rewarding to see what we have accomplished. However, it is not all me. It is the fine people that I work with and our customers that have supported us for so many years and continue to do so now. They are the ones who have made Yuengling what it is today. Our expectation is that the company will continue to grow as we expand into new markets in the near future, and we hope that more people will continue to recognize the fine beers and historic legacy that originated here in Pottsville.

If you enjoy this book and the history that you see before you, I hope that you will consider coming to Pottsville to join the thousands of others who tour our brewery every year. Whether it is seeing our 19th-century brewhouse built into the side of Sharp Mountain; or walking through the underground lagering caves that were dug out by hand; or having a beer in our rathskeller, built in 1933 to celebrate the end of Prohibition; or seeing our museum that showcases more than a century of Yuengling advertising and memorabilia, we think you will enjoy taking part in the Yuengling experience!

—Dick Yuengling

ACKNOWLEDGMENTS

I would like to thank the owner and president of D.G. Yuengling & Son, Inc., Dick Yuengling. I first met Dick on a visit to the brewery in 2011, and he was as cordial and helpful as his father had been when I first visited the brewery in 1979. He generously allowed me to photograph any and all items in the brewery and museum for my book projects, even items that were one-of-a-kind and priceless. The addition of these many images gave the book a much greater degree of historic relevance. We are fortunate that early Yuengling family members had the foresight to photograph the brewery extensively and that more recent family members have maintained this collection of images and have made them available for others to view and enjoy. In addition, we are fortunate that the company was able to maintain such a huge collection of rare vintage advertising, some more than a century old.

In addition, I would like to thank the following: Debbie Altobelli, the brewery tour coordinator, who was my "go-to" person when I needed information or just about anything else; Amy Whitehead for sending a huge compilation of additional brewery images that were not available in the museum; Bob Seaman, my tour guide at the Mill Creek plant in 2011; Jenn Kruss, the gift shop coordinator; and Jen Holtzman of marketing.

I would also like to thank Rich Wagner, Herb and Helen Haydock, Dave Gausepohl, Dale Van Wieren, and Ryan and Liz Kehler. I also wish to acknowledge Mark A. Noon, the author of *Yuengling: A History of America's Oldest Brewery*. Released in 2005 by McFarland & Company, Inc., Publishers, it gives a highly detailed history of the family and the company and provided a great deal of background information for this book.

Thanks also go to Abby Henry, my editor at Arcadia Publishing, for her enthusiasm and guidance during the production of this book. It was actually Abby who had approached me regarding this book project, in which I feel honored to have taken part.

Finally, I would like to thank my wife, Jenny, and my daughters, Ana, Alex, and Athena, for allowing me to pursue my loves of history and writing.

Images are from the author's collection unless otherwise noted.

INTRODUCTION

When it comes to beer, the Yuengling name has been a part of life in eastern Pennsylvania for several generations. However, in recent years, the name has been spreading all along the East Coast and into areas far removed from the company's home in Pottsville, Pennsylvania. Certainly the company's growing popularity has a lot to do with the high quality of the beers it produces, but there is more to it. Having been in business for more than 180 years, operated by the same family that entire time, and having survived intense competition from the likes of huge, aggressive corporate brewers such as Anheuser-Busch, Miller, and Coors also play roles in Yuengling's growing popularity. Even beyond that, the company has an almost mystical quality associated with it, one that has created fans throughout the country who are clamoring to have the beer sold in their states.

Although the company currently operates three separate breweries, its original plant on Mahantongo Street, known as America's Oldest Brewery, is the one that is most associated with the company's history-oriented image. The old brewery is indeed a special place, largely for the reasons stated by Dick Yuengling in the foreword. One can immediately sense this when taking a tour of the plant, whether it is seeing the stained-glass ceiling above the brew kettle, going underground into the storage caves, having a beer in the rathskeller, or seeing the company's museum in the gift shop. On top of all that, knowing that beer was being brewed at this same site in 1831 is something no other brewery in the United States can boast of.

My own introduction to the Yuengling brewery came in June 1979, at the age of 16 and at the height of the disco era. My parents and I braved widespread gasoline shortages and a recent near-disaster at the Three Mile Island nuclear plant an hour away at Harrisburg to travel from northeast Ohio to Pottsville. I was not quite sure what to expect upon arriving at the brewery unannounced in the middle of the afternoon, but based on experiences elsewhere, I figured the office might have some empty cans to sell for collectors. What came as a shock was the company's owner and president, Richard Yuengling Sr., coming down to greet us, thanking us for visiting, and amazingly enough, taking us on an hour-long tour of the entire brewery. He could not have been nicer to me and my parents. What I also realized years later was how proud he was of this brewery, a remarkable gift that had been handed down to him by generations of his family, and he wanted to share that gift with others. I found later that he did this for many visitors, and I am sure that most of them were as surprised as we were. I became a lifelong fan of Yuengling beer that day, even if I was a few years away from being able to have one to drink.

The history of this fascinating company is told here through more than 220 images of people, buildings, equipment, advertising, labels, trucks, and more. It is aimed at history buffs, collectors of brewery artifacts (or "breweriana"), and anyone who enjoys drinking any of the fine Yuengling beers available. In fact, it is a good book to read while sipping a cold Yuengling Lager, Porter, Black & Tan, or Lord Chesterfield Ale. Cheers!

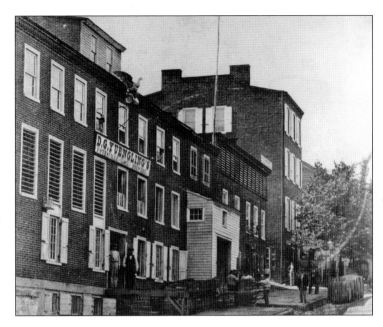

This is the earliest known photograph of the brewery, c. 1850s and looking west along Mahantongo Street, with the brewhouse in the foreground. The building next to that was later enlarged to create the present-day, five-story brewhouse. In the background, on the far side of Fifth Street, is the Yuengling family's four-story home. Built in the 1840s, it was known as "the Old Homestead." (Courtesy of D.G. Yuengling & Son, Inc.)

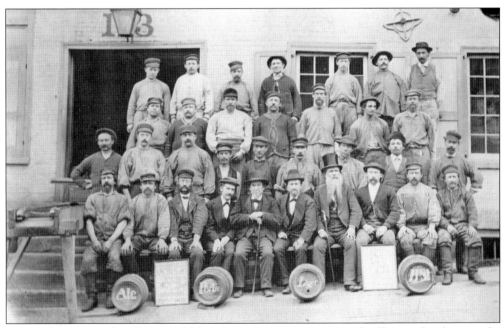

One tradition carried on by many 19th-century brewers was to periodically pose for photographs with their employees outside their breweries. Here, David G. Yuengling (sitting in the first row, fifth from left) poses with his employees outside the Eagle Brewery brewhouse in the late 1860s. (Courtesy of D.G. Yuengling & Son, Inc.)

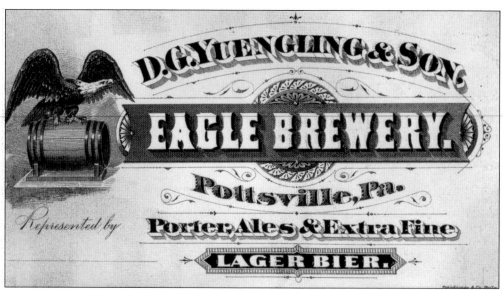

TAKE NOTICE!

That by **Section 2**, of an **Act of Assembly** of the **Commonwealth of Pennsylvania**, approved the 4th day of April, A. D. 1865, it is declared **unlawful** for any person, other than the lawful owner, to use, traffic, or purchase, sell, dispose of, detain, convert, mutilate or destroy, or wilfully or unreasonably refuse to return or deliver to the owner, any barrel, cask or keg used by him in the manufacture and sale of **Malt Liquors;** or to remove, cut off, deface or obliterate such brands or stamps; and any person so offending shall, upon conviction, be deemed guilty of a misdemeanor, to be punished, for the first offence by a fine of **Ten Dollars ($10)**, for each and every such barrel, cask or keg so used, disposed of, detained, converted, mutilated or destroyed, or not so returned or delivered, and by a fine of **Twenty Dollars ($20)**, and by an imprisonment in the County Jail for not less than *one* nor more than *three months* for each and every subsequent offence. Therefore, Notice is hereby given, that the undersigned will prosecute to the full extent of said Act of Assembly, any and all persons, who, in violation thereof, shall use, purchase, sell, dispose of, detain, convert, mutilate or destroy, or refuse to return or deliver to him or his agents or drivers, any barrel, cask or keg, used by him in the manufacture *or* sale of Malt Liquors, he having branded *or* stamped his name **"YUENGLING"** or **"D. G. YUENGLING"** on both heads *of each and every barrel, cask or keg.*

D. G. YUENGLING.

Eagle Brewery, Pottsville,
September 28th, 1865.

From the beginning, Yuengling's company was known as the Eagle Brewery. Representing strength and pride, the eagle logo remains on all Yuengling products to this day. This is a trade card used by the company's salesmen in the 1880s. (Courtesy of D.G. Yuengling & Son, Inc.)

Dated from September 1865, this notice was posted at multiple sites in the region in an attempt to discourage theft of the company's barrels. The fine of $10 along with one to three months of jail time was a significant deterrent. This particular notice was still in use as of 1873, when Frederick Yuengling joined his father in the business; one can faintly see "and son" written in pencil at the bottom after "Yuengling."

This is likely the earliest photograph of the newly enlarged brewhouse, taken c. 1875. It had recently been enlarged from two to five stories in height and featured large louvered panels on the upper floors instead of windows, to allow for easier cooling during the brewing process. Founder David G. Yuengling is standing with a cane next to the lamppost. (Courtesy of D.G. Yuengling & Son, Inc.)

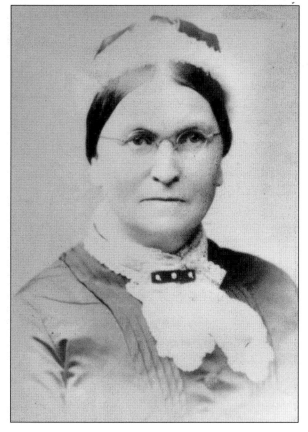

David Yuengling married Elizabeth Betz, shown here, in 1841. Fifteen years his junior, she bore him three sons and seven daughters during their marriage. Her brother John Betz trained at the Yuengling brewery before moving to Philadelphia, where he became one of the city's major early brewers. (Courtesy of D.G. Yuengling & Son, Inc.)

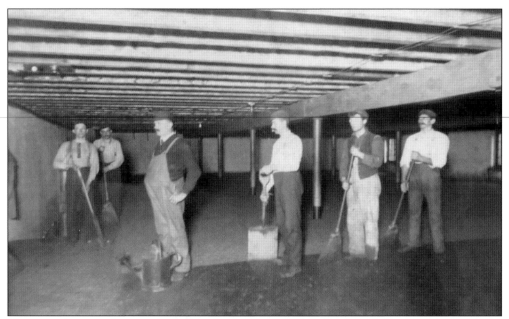

This view shows workers inside the brewery's malting plant around 1900. Here, barley seeds were spread out on the floor and allowed to germinate, after which they were dried to make malt that would then be used in the brewing process. (Courtesy of D.G. Yuengling & Son, Inc.)

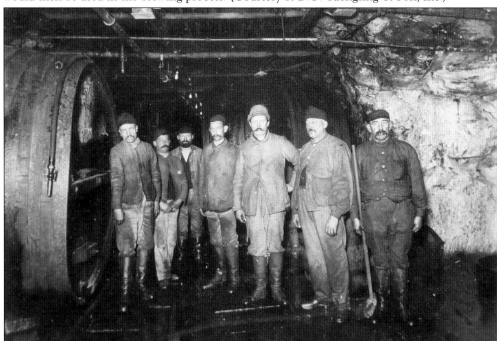

An extensive series of caves was dug into the hill beneath the brewhouse in the mid-1800s, in conjunction with the introduction of lager beer around the same time. The lagering process required cool temperatures and longer aging than ale or common beer, and it would ultimately prove to be the company's most popular style. These workers are shown c. 1900 in the caves, which were cold, dank places to work in. (Courtesy of D.G. Yuengling & Son, Inc.)

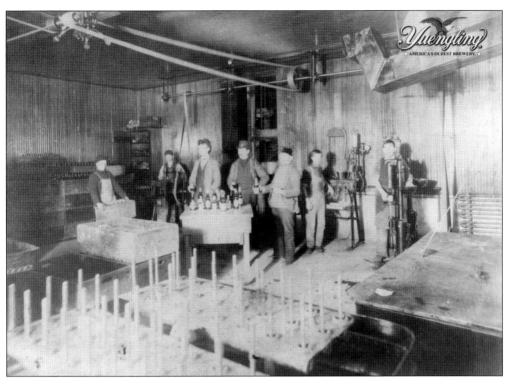

By the 1890s, bottled beer still represented a very small portion of Yuengling's output, most of which was in barrels for saloon sales. Bottles were meant to be returned to the brewery, where they would be thoroughly cleaned and reused. This view inside Yuengling's bottling room is from that era and shows the rods on which bottles were placed upside down to dry after being washed. (Courtesy of D.G. Yuengling & Son, Inc.)

This view of the brewhouse was taken c. 1890, after the addition of the company name to the front. Horse-drawn beer wagons stand in front of the building, waiting to be loaded with barrels. (Courtesy of D.G. Yuengling & Son, Inc.)

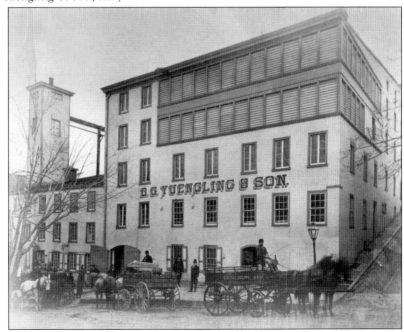

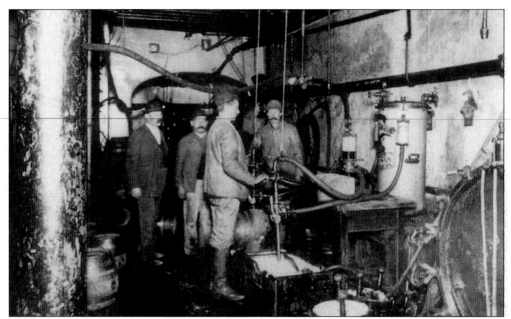

These two images, taken c. 1900, show the racking process, in which finished beer was siphoned into barrels just prior to being shipped out to saloons. Racking was fairly labor-intensive compared with today's largely automated process, and it took place in the lagering caves underneath the brewery. In the image below, the man bending over in the center of the room was moving at the time of the photograph, giving him a ghostly appearance. (Both, courtesy of D.G. Yuengling & Son, Inc.)

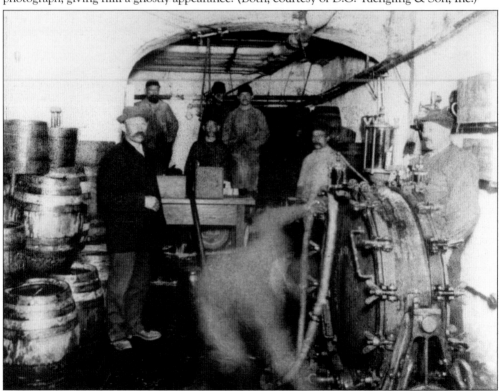

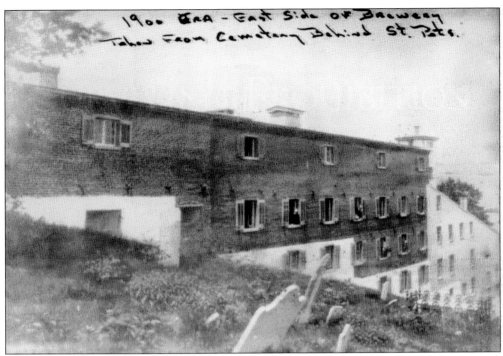

This unusual view of the Yuengling brewery is taken from the cemetery behind St. Patrick's Catholic Church, next door to the brewery, around 1900. The white building at the far right faced Mahantongo Street and was the original brewhouse, built in 1831. After the newer brewhouse was constructed on its west side, the building was used for malting, bottling, and storage. The steep grade of the hill is clearly seen here. (Courtesy of D.G. Yuengling & Son, Inc.)

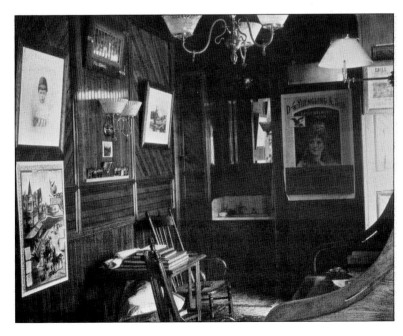

This view shows the interior of the Yuengling brewmaster's office c. 1900. The walls are adorned with various posters, one of which is a recent Yuengling calendar. Also on the wall is the old framed advertisement previously seen on page 10. (Courtesy of D.G. Yuengling & Son, Inc.)

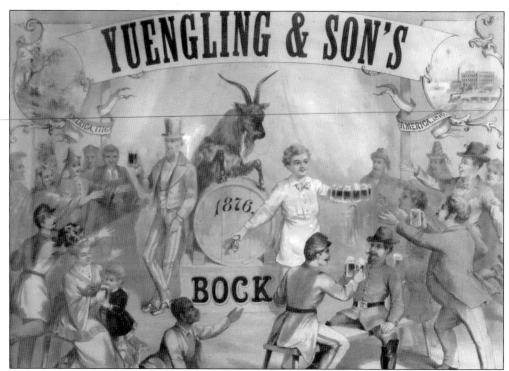

This 1876 lithograph is one of the earliest known advertisements for the brewery. The festive and patriotic scene is a stock advertisement, meaning that it was a generic preexisting image that was chosen by Yuengling, after which the company name was printed at the top. As bock beer was only available for a few weeks in the spring, the lithograph would not likely have been in use for long. (Courtesy of D. G. Yuengling & Son, Inc.)

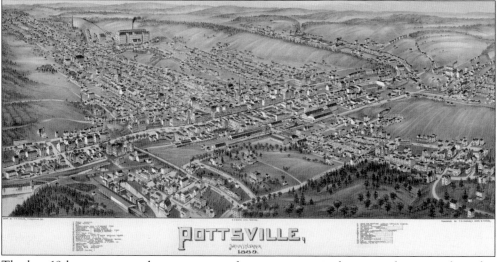

The late 19th century saw the appearance of many panoramic drawings of cities, such as this one of Pottsville as it appeared in 1889. Drawn and published by T.M. Fowler long before aerial photography was available, it shows the city in great detail, looking due west, and gives one an idea of the hilly landscape in which Yuengling developed. Sharp Mountain is at the far left, and the brewery can barely be seen in the middle left portion of the drawing.

Two

THE NEXT GENERATIONS TAKE OVER

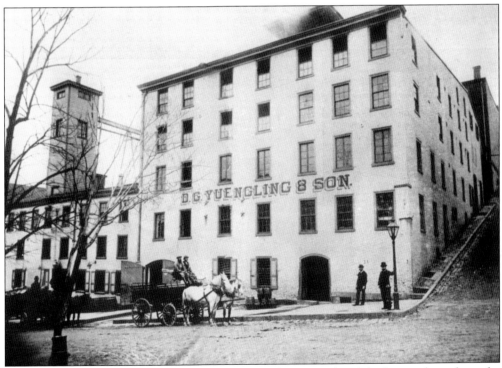

A later view of the brewery, c. 1900, shows windows having replaced the louvered panels on the upper floors, as the building had taken on the appearance that it retains to this day. By this time, the plant covered three city blocks and was producing 65,000 barrels of beer, ale, and porter every year. The original brewhouse at left, some 70 years old, remained in use for malting, bottling, and storage. (Courtesy of D.G. Yuengling & Son, Inc.)

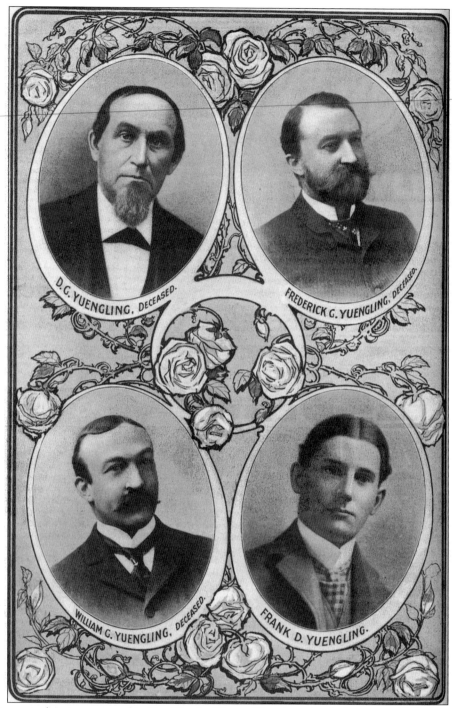

This ornate drawing appeared in *One Hundred Years of Brewing*, a book that was published in 1903 chronicling the history of the American brewing industry. It shows the first two generations of brewery ownership with David, Frederick, and William Yuengling, who were all deceased by this time. It also shows the third generation of ownership with a young Frank Yuengling, who would continue to oversee the company's operations until his death in 1963, for a total of 64 years.

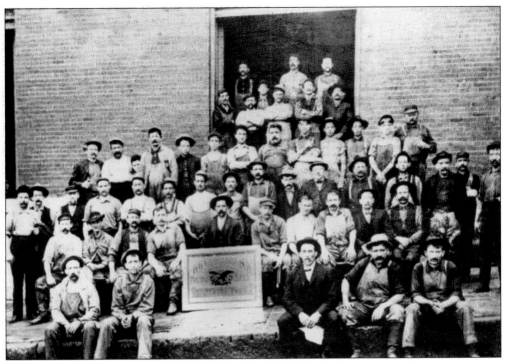

Yuengling employees gathered together again two more times to pose for photographs, as seen previously on page 5. The photograph above was taken around 1890, and the photograph below was taken around 1900. In some cases, such photographs provide the only known images of these individuals. (Both, courtesy of D.G. Yuengling & Son, Inc.)

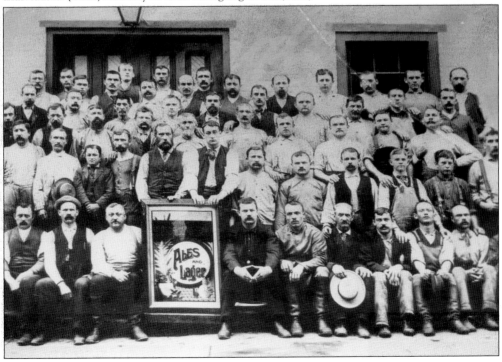

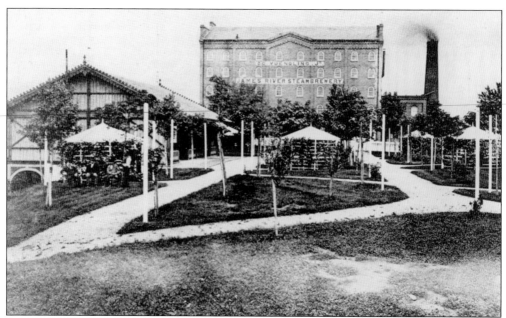

David G. Yuengling's eldest son, David Jr., was an enterprising brewer as well. Leaving Pottsville around 1866, he became involved with the construction of a large new brewery at 912 East Main Street in Richmond, Virginia. Doing business as the James River Steam Brewery, the plant remained in operation until 1878. (Courtesy of D.G. Yuengling & Son, Inc.)

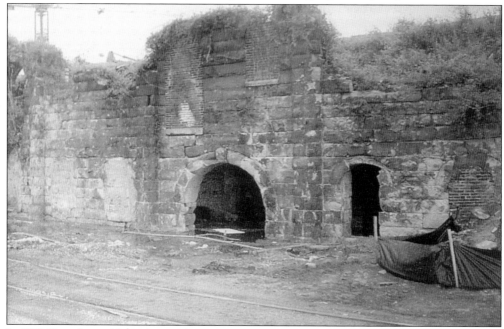

In 1878, Yuengling sold the plant of the James River Steam Brewery to a company that manufactured ice cream freezers, and it remained occupied for a number of years. The building is no longer standing, although its underground lagering caves remain partially intact. The entrance to these, shown here, remains visible along the edge of the James River. (Courtesy of D.G. Yuengling & Son, Inc.)

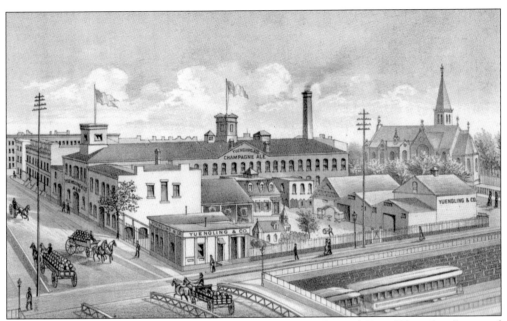

Even while still overseeing the operation of the brewery in Richmond, David Yuengling Jr. moved to New York City around 1871, where he established a brewery at Fifth Avenue and 128th Street in present day Harlem for the production of Champagne Ale. Although this plant was producing nearly 30,000 barrels annually by the end of the decade, it was closed in 1882 due to the decreasing popularity of ale in favor of lager beer. The brewery is shown here in an 1880 image from the *Western Brewer*, an early brewing industry magazine.

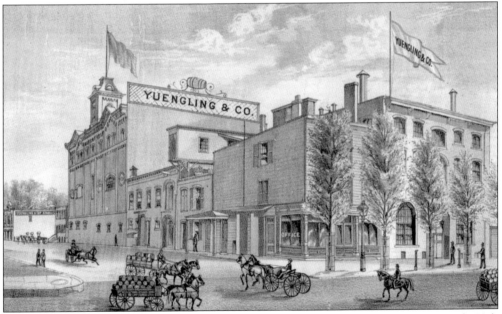

In 1875, Yuengling also purchased the existing Manhattan Brewery at Tenth Avenue and 128th Street for production of the much more popular lager beer. Shown here in an 1880 image from the *Western Brewer*, this plant was much larger than the ale brewery and was producing nearly 60,000 barrels annually by 1879 and more than twice that number by 1895.

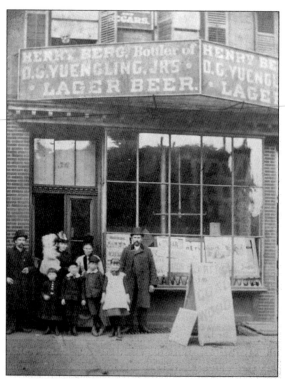

Nineteenth-century saloon owners and their families frequently lived in the same buildings as their drinking establishments, and many photographs exist of their wives and children posing with them outside the premises. This c. 1890s view shows a New York City saloon that served beer from David Yuengling Jr.'s Manhattan Brewery.

The Manhattan Brewery was later enlarged and remained in business until the onset of Prohibition, although Yuengling had sold his share of the company by 1897. The plant reopened as a brewery after Prohibition ended, operated by the Horton Pilsner Brewing Company until 1941. Known today as the Mink Building, it has been renovated for office space. This picture shows a delivery wagon used by the brewery in the 1890s. (Courtesy of D.G. Yuengling & Son, Inc.)

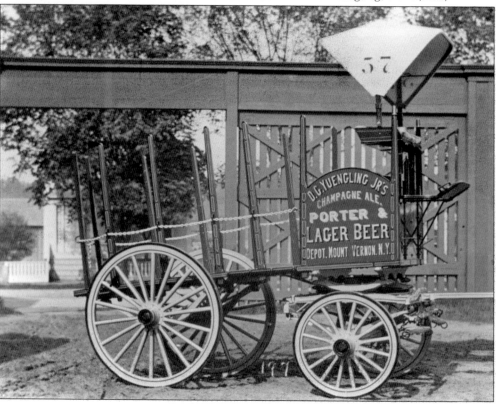

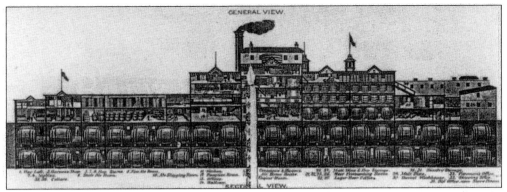

This drawing shows a cutaway view of the Yuengling Manhattan Brewery in the 1880s, revealing the extensive underground lagering cellars that were used in the days before mechanical refrigeration was available. This situation was easier to handle in the original Pottsville brewery, built into the side of a steep hill where lagering cellars could be excavated with greater ease. (Courtesy of D.G. Yuengling & Son, Inc.)

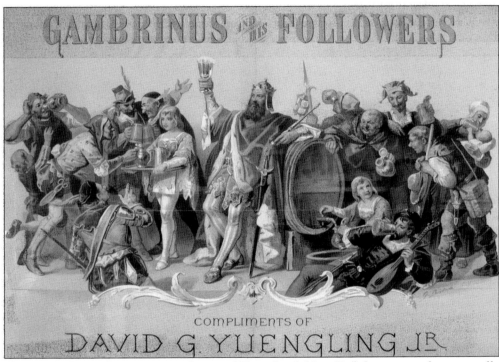

This rare lithograph from 1880 advertised Yuengling's New York brewery without actually mentioning "beer." King Gambrinus was the legendary patron saint of brewing, and his image has been widely used in brewery advertising. Although his identity is not certain, Gambrinus is often thought to have been John the Fearless, Duke of Burgundy, from the early 15th century. (Courtesy of Herb and Helen Haydock and the Minhas Brewery Beer Memorabilia Museum in Monroe, Wisconsin.)

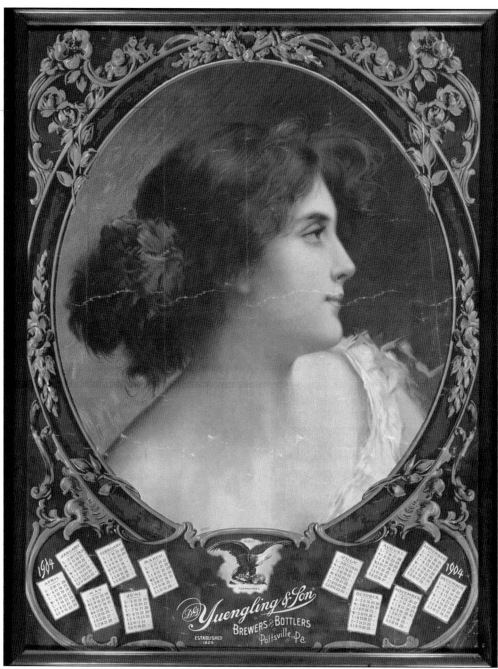

Like many brewers of the era, Yuengling had large lithographed calendars produced on a yearly basis to use as gifts for saloon owners and distributors. The graphics were ornate and colorful and typically portrayed either women or other attractive scenes. As they were not meant to last, most were either discarded or deteriorated quickly. The few that have survived today are highly prized by collectors. This calendar is from 1904 and was reproduced by the brewery in recent years as a poster. (Courtesy of D.G. Yuengling & Son, Inc.)

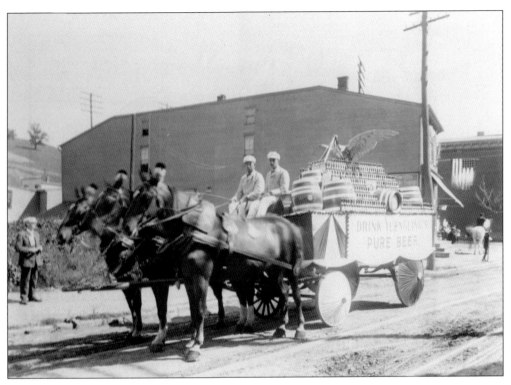

Shown here are two views of a horse-drawn wagon loaded with Yuengling Pure Beer that took part in a holiday parade c. 1910. Yuengling, like many brewers of the era, had a strong sense of community and often took part in such local events, as they provided a good opportunity for advertising. (Both, courtesy of D.G. Yuengling & Son, Inc.)

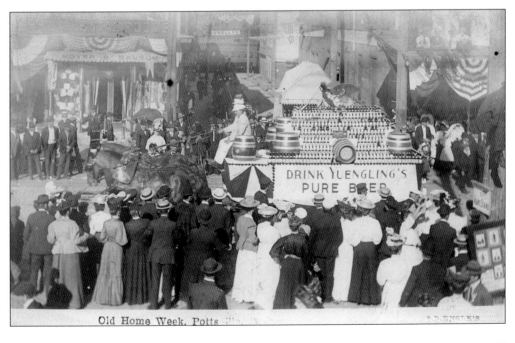

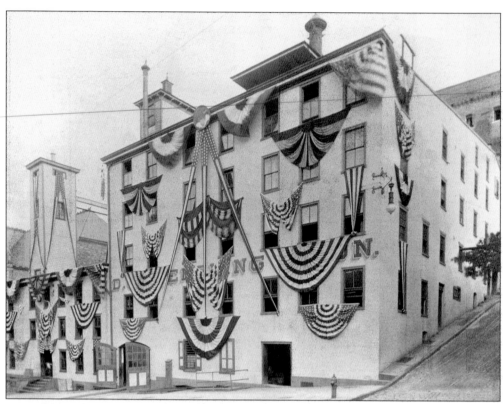

The Yuengling brewery buildings were decorated to the fullest with flags and banners for an Independence Day celebration c. 1910. There appeared to be little activity at the brewery over the holiday. (Courtesy of D.G. Yuengling & Son, Inc.)

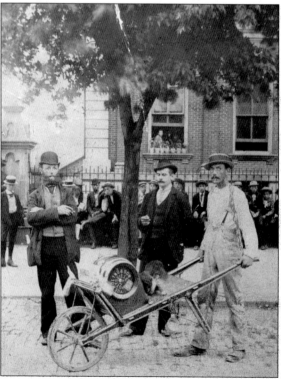

Charles J. Guetling was a German immigrant who lived in Pottsville and made a promotional walking trip from Pottsville to the 1893 World's Fair in Chicago. What made his nearly 900-mile, 28-day trip unique was that he pushed a full barrel of Yuengling Beer the entire way on a wheelbarrow, with his dog Prince as a passenger. Upon his return home, the brewery paid him $25 for his trouble. The publicity for the company was priceless. (Courtesy of D.G. Yuengling & Son, Inc.)

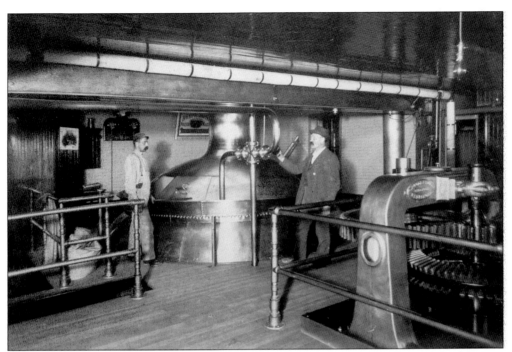

The view above shows the copper brew kettle inside the brewhouse as well as a Yuengling sign hanging on the wall c. 1900. At the right are some of the gears involved with operation of the equipment, a common sight inside early factories. These large gears turned quickly and with much force, leaving the potential for gruesome injuries until later years when such gears and other dangers were covered and kept away from workers. Below is a view of the cereal cooker; both of these devices were installed in the new brewhouse in 1876. (Both, courtesy of D.G. Yuengling & Son, Inc.)

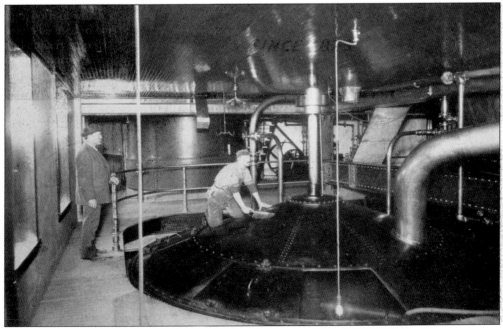

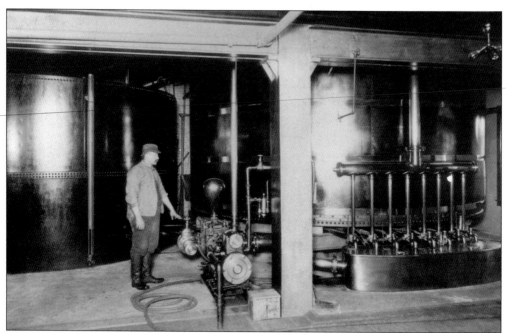

This view, taken c. 1900, shows the lauter tun (a "tun" being another term for a tank), also installed with the original brewhouse equipment in 1876. Inside this vessel, the solid remnants of the cooked malt were separated from the liquid, known as wort, before the liquid was pumped into the brew kettle. (Courtesy of D.G. Yuengling & Son, Inc.)

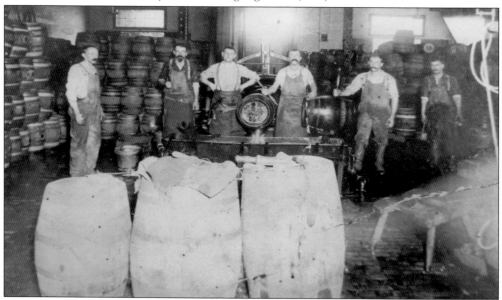

Wooden barrels were a necessity for early brewers as the only practical way to send beer to saloons for sale. Most 19th-century brewers maintained their own cooperage, where barrels were made and maintained. To prevent leakage, a petroleum derivative known as pitch was heated and applied to the barrel's interior. Barrels required repitching periodically along with other repairs. This view shows the interior of the Yuengling cooperage c. 1900. (Courtesy of D.G. Yuengling & Son, Inc.)

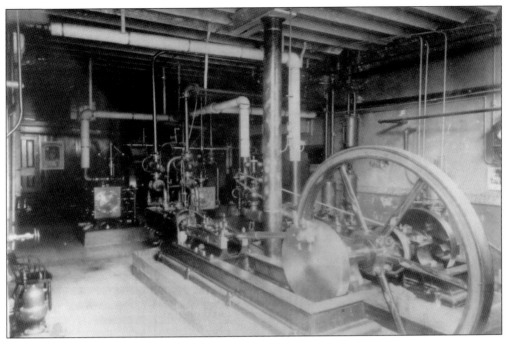

Shown here are two views of the machinery inside the Yuengling engine room in the early 1900s. Steam produced by the coal furnace was piped to this area where it turned the generators, creating electricity that powered the remainder of the plant. This equipment is no longer in place. (Both, courtesy of D.G. Yuengling & Son, Inc.)

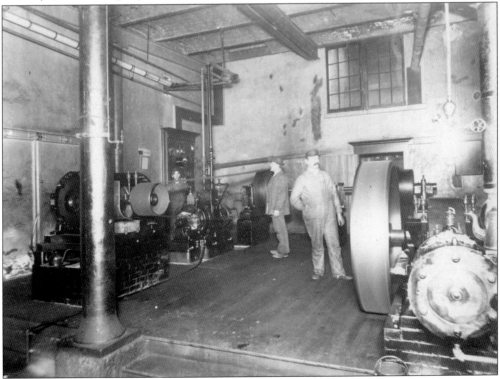

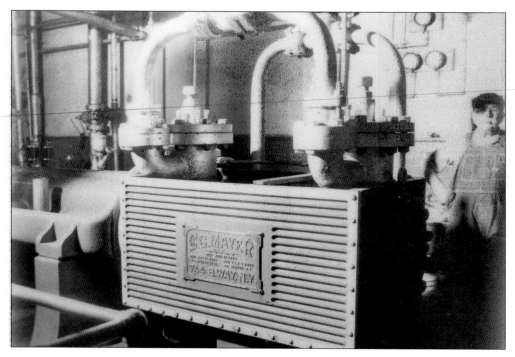

Yuengling's underground caves allowed beer to age at a constant cool temperature, which was a requirement for lager beer. By the late 19th century, however, the advent of mechanical refrigeration allowed brewers to keep their beer aboveground in refrigerated cellars. The view above shows a close-up of an ammonia compressor used by Yuengling in the refrigeration process c. 1910. Below is a view of more refrigeration equipment. (Both, courtesy of D.G. Yuengling & Son, Inc.)

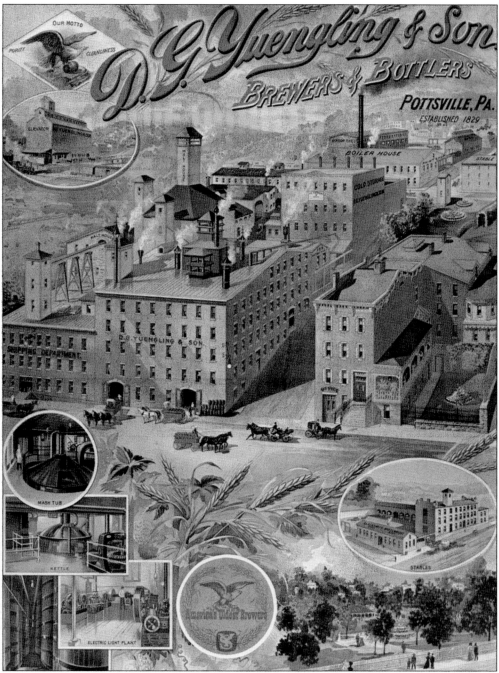

Factory-scene lithographs were a common form of industrial advertising around the turn of the 20th century. While many companies used images that were drawn with considerable artistic license to make their plants look much larger than they actually were, this one for Yuengling, created c. 1900, is reasonably accurate. In addition to showing images of the brewery both inside and out, it shows Yuengling Park, which was several blocks away and contained a structure that housed the company's water source at the time, a hillside spring and small reservoir. This image has been reprinted by the brewery as a poster in recent years. (Courtesy of D.G. Yuengling & Son, Inc.)

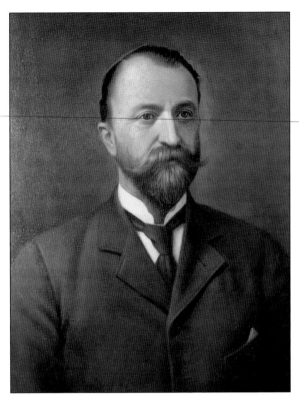

Frederick Yuengling, born in 1848, was educated at Penn State University in State College before attending business school and spending significant time in Europe, where he trained at breweries in Munich and Vienna. He became the brewery's president upon the death of his father in 1877, remaining in that position until his untimely death in 1899. This painting of Frederick hangs in the brewery today. (Courtesy of D.G. Yuengling & Son, Inc.)

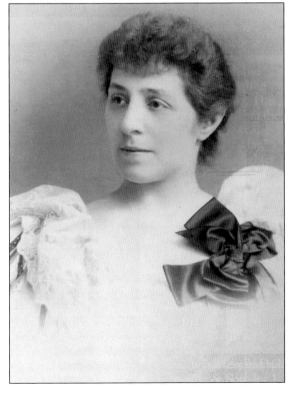

Minna Dohrman grew up in Brooklyn, New York, where she met Frederick Yuengling in the early 1870s. The couple was married in 1873 as he was finishing his education, and they moved to Pottsville shortly thereafter as he became a full partner with his father in the family business. After Frederick's death in 1899, Minna found herself in a position of managing the brewery along with her 22-year-old son Frank, and she proved to be an able businesswoman in the coming years. (Courtesy of D.G. Yuengling & Son, Inc.)

By the 1890s, Yuengling beers were being sent by train to towns throughout the region, and storage depots like those shown here in Hazleton (right) and Tamaqua (below) began to appear. Essentially just insulated icehouses used to store barrels of beer, similar buildings were constructed in Shenandoah, Centralia, Mahanoy City, Mount Carmel, Ashland, and Girardville. Beer was also shipped to distributors scattered throughout eastern Pennsylvania and could even be found at selected taverns in Philadelphia, Boston, and New York City. (Both, courtesy of D.G. Yuengling & Son, Inc.)

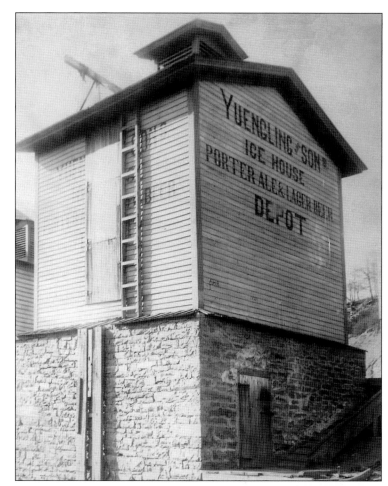

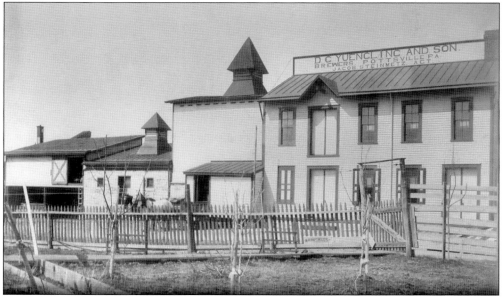

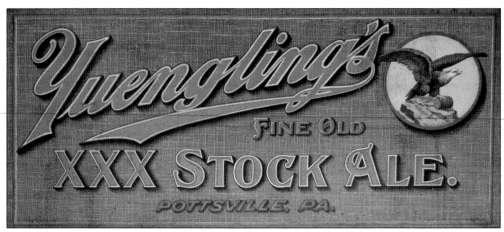

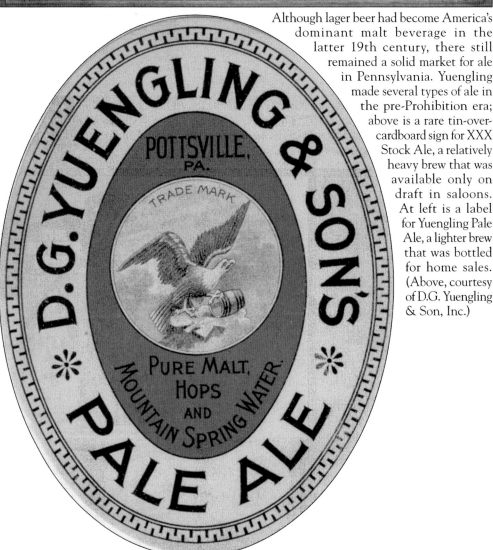

Although lager beer had become America's dominant malt beverage in the latter 19th century, there still remained a solid market for ale in Pennsylvania. Yuengling made several types of ale in the pre-Prohibition era; above is a rare tin-over-cardboard sign for XXX Stock Ale, a relatively heavy brew that was available only on draft in saloons. At left is a label for Yuengling Pale Ale, a lighter brew that was bottled for home sales. (Above, courtesy of D.G. Yuengling & Son, Inc.)

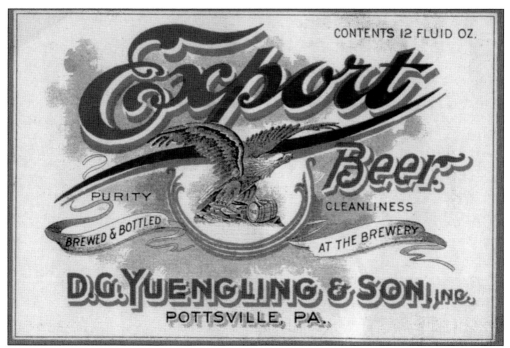

Shown here around 1905 are two bottle labels. The one above is for Yuengling Export Beer, the standard brand that was bottled and sold throughout the region. Below is a label for the company's bock beer, available for a few weeks each spring. Bock beer is thought to have originated in the Middle Ages and was produced by most American brewers into the mid-1950s. It was supposedly made of the highest quality ingredients and had a richer, more full-bodied taste than regular beer. Its appearance was traditionally celebrated as a sign of spring's arrival. (Below, courtesy of D.G. Yuengling & Son, Inc.)

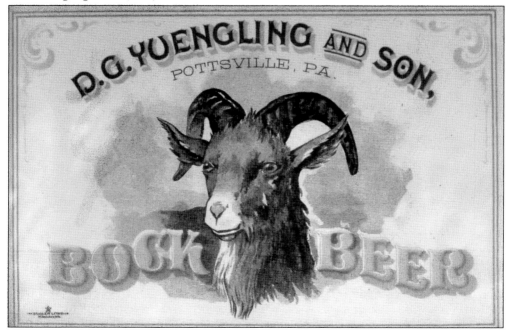

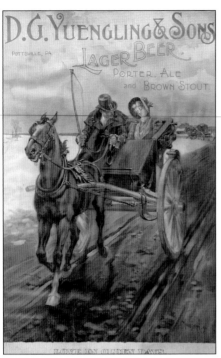

This image shows an advertising lithograph from the 1890s, now on display in the Yuengling gift shop and museum. While many similar lithographs were used by the company over the years, very few have survived to this day. (Courtesy of D.G. Yuengling & Son, Inc.)

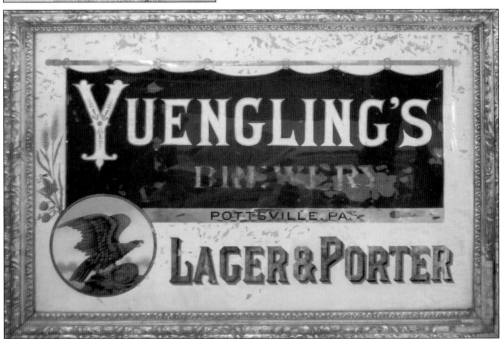

Large glass signs like this one were produced to hang in saloons, drawing the attention of patrons to the brand advertised. Yuengling used several different designs of these over the years, a few examples of which have survived. This sign, also from the Yuengling gift shop museum and more than a century old, shows one of the down sides of painted glass: the signs were not meant to last long term, and scattered flakes of paint have peeled off over the years. (Courtesy of D.G. Yuengling & Son, Inc.)

Two more lithographed advertisements are shown here, both between 1900 and 1910. With nostalgia playing a significant role in much of Yuengling's modern advertising as a nod to the company's history, graphics on these and other similar advertisements have been reused on a number of occasions. (Both, courtesy of D.G. Yuengling & Son, Inc.)

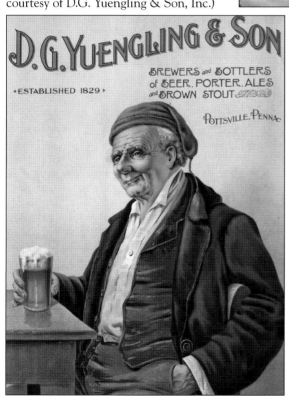

THE BREWINGS FROM

D. G. YUENGLING & SON'S

..Eagle Brewery..

Are Endorsed

By Physicians, By Professional Men,
By Clergymen, By the Public in general.

.

Clean, pure spring water. clean hops, and a clean brewery combine to make its brewings

Clean, Pure and Wholesome.

YUENGLING'S BROWN STOUT has a National reputation, and stands without a rival.

Wiener and Lager Beers are Popular Brews.

Long before radio and television became realities, newspapers were the primary format for communication of information. They also provided breweries with an opportunity to advertise their products to a wide cross-section of society. This advertisement was placed in the *Pottsville Republican* in May 1897 and stressed the plant's cleanliness as well as featuring endorsements by upstanding members of society.

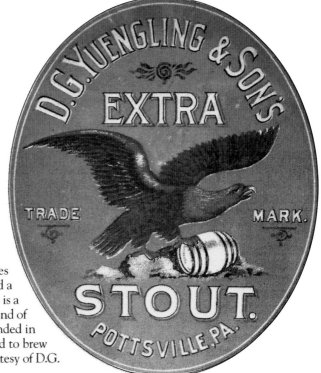

Stout is a type of porter that uses darker malt and has more body and a higher specific gravity. Shown here is a rare bottle label for Yuengling's brand of stout. While production of stout ended in the 1910s, Yuengling has continued to brew its porter to the present day. (Courtesy of D.G. Yuengling & Son, Inc.)

Porter is a type of ale that uses roasted malt, giving it a dark brown color and heavier taste than standard ale or beer. Originating in England, it had a large following in New England and Pennsylvania during the 1800s, but aside from the Yuengling brand, it was gradually phased out of production by most brewers after the turn of the 20th century. This is a bottle label for Yuengling Porter c. 1910. (Courtesy of D.G. Yuengling & Son, Inc.)

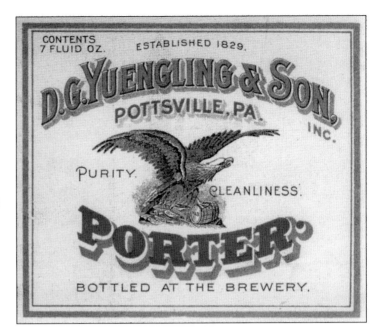

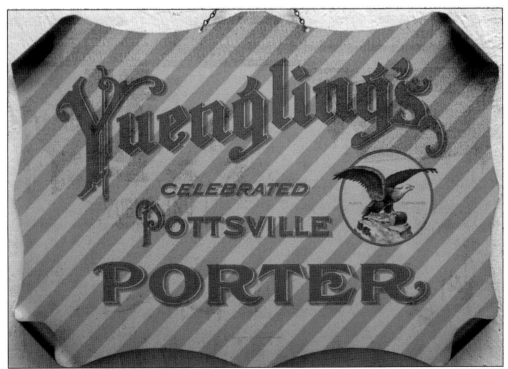

Yuengling's Pottsville Porter was one of the most well-known porters in the eastern part of the country. It was often advertised as being recommended by doctors due to its supposed health-giving properties (some porters were marketed to nursing mothers and invalids as nutritional supplements). This is a tin sign for the brand c. 1910. (Courtesy of D.G. Yuengling & Son, Inc.)

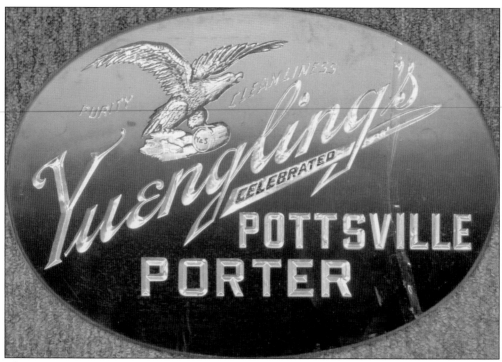

These are two more varieties of reverse-on-glass signs from saloons from the 1890s. The use of glass sometimes gave these signs a mirror effect, and metallic paint on the inside surface gave a shimmering effect to the eagle and lettering. Any aspects that could get the attention of a saloon patron, whether it was bright colors, attractive designs, or other effects, could help to sell more beer. (Both, courtesy of D.G. Yuengling & Son, Inc.)

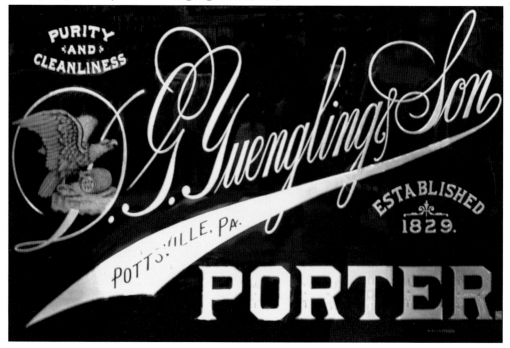

Most early brewers employed coopers, or barrel makers, to produce the wooden barrels that were filled with beer to sell to saloons, as this was the primary mode of sales before bottled beer became commonplace. This picture shows coopers that worked for David Yuengling Jr.'s brewery in New York c. 1890. (Courtesy of D.G. Yuengling & Son, Inc.)

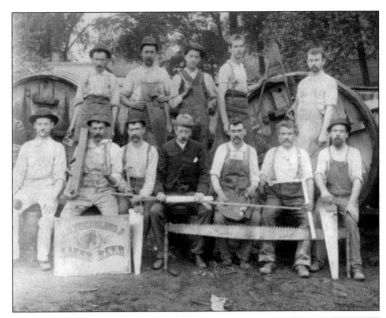

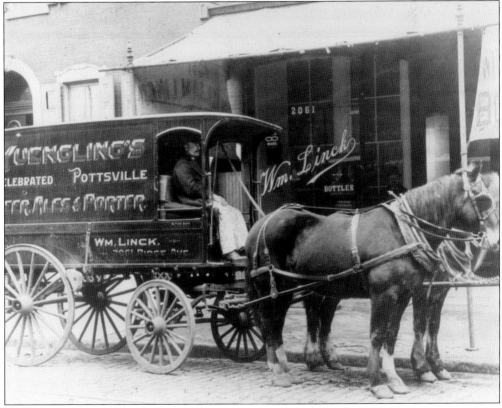

As time went by and regional transportation became more extensive, Yuengling Beer was increasingly shipped out of Pottsville and into the huge market of Philadelphia. This photograph from 1910 shows a horse-drawn wagon used by distributor William Linck, who would accept Yuengling Beer in large casks and then bottle it for local sales. (Courtesy of D.G. Yuengling & Son, Inc.)

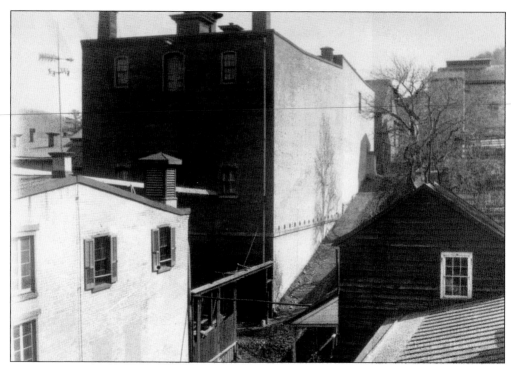

Up the hill from the brewhouse stood this three-story refrigerated stockhouse, used for storing beer during the fermenting and aging processes. Seen here around 1900, the building was replaced by a newer structure after Prohibition's end. (Courtesy of D.G. Yuengling & Son, Inc.)

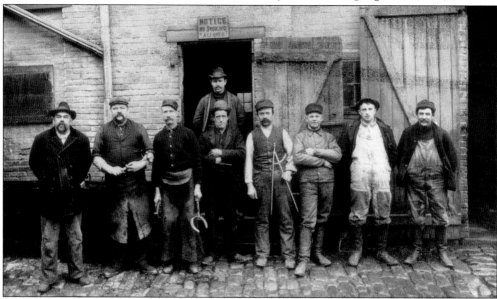

By the late 19th century, Yuengling had roughly 30 teams of horses to pull its beer wagons up and down the many hills in Pottsville and the surrounding region. The presence of so many horses required the brewery to have its own blacksmith shop one block away at Fifth and Norwegian Streets. Shown here are some of the blacksmiths that worked for the company. (Courtesy of D.G. Yuengling & Son, Inc.)

Pre-Prohibition saloons often used small trays like these for patrons to leave tips for bartenders. Many breweries advertised on these trays like they did on the larger serving trays, and Yuengling was no exception. Generally measuring just over four inches in diameter, these have also become prized by collectors in recent years. (Both, courtesy of Joe Gula.)

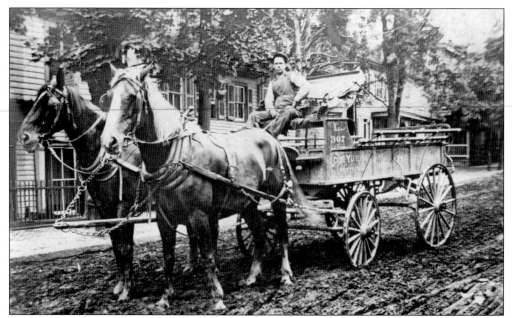

By 1900, small wagons such as this were still in use for local deliveries in and around Pottsville. These smaller wagons had one particular advantage: being lighter, they were less likely than the larger, heavier wagons to get stuck in mud when loaded with full barrels. This image shows in good detail the poor quality of the dirt roads during the rainy fall, winter, and spring seasons. (Courtesy of D.G. Yuengling & Son, Inc.)

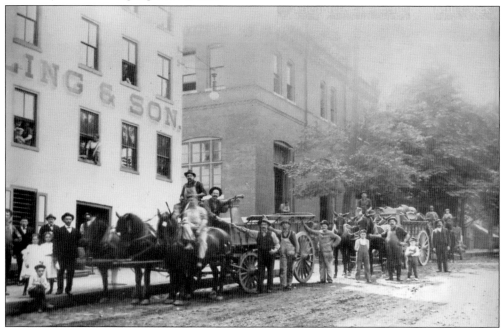

Posing for photographs was a special event in the late 1800s. This image shows not only two horse-drawn beer wagons in front of the Yuengling brewhouse, but also shows several children on the sidewalk and in the windows of the building, most dressed in their finest clothes. (Courtesy of D.G. Yuengling & Son, Inc.)

Prior to 1900, breweries had limited opportunities to promote their products, with most advertisements appearing either in newspapers or directly in saloons. Some of the most ornate and delicate signs were those that hung in dark, smoky taverns. This sign was of a particular style known as reverse-on-glass, and exists in two varieties, one with a red background and one with a white background. The very few that have survived to this day typically command a high price from collectors. (Courtesy of D.G. Yuengling & Son, Inc.)

Serving trays were used in most early saloons and provided breweries with another good opportunity for advertising. This ornate tray was produced for Yuengling in 1911 by the American Art Works Company of Coshocton, Ohio, a well-known manufacturer of trays and other metal signs. (Courtesy of D.G. Yuengling & Son, Inc.)

47

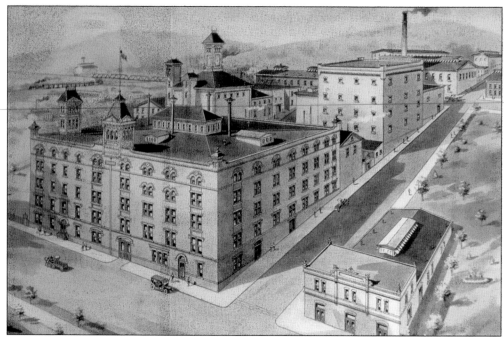

By the early 20th century, most breweries had begun to enlarge and modernize their plants, reflecting technological improvements of the brewing process that took place within. The most common feature seen in breweries built around this time was a prominent, ornate brewhouse, four to six stories in height. This drawing shows an architect's proposal for such an addition to the Yuengling plant, around 1905. For unknown reasons, Yuengling did not proceed with these plans, leaving the older buildings intact. (Courtesy of D.G. Yuengling & Son, Inc.)

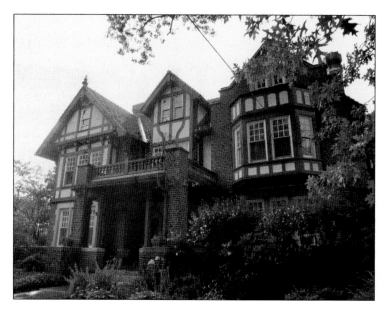

The Yuengling mansion stands today at 1440 Mahantongo Street, just blocks from the brewery. The huge Tudor-style home was built by Frank Yuengling between 1911 and 1913, and his five children grew up here. It continued to be the family home until 1978, after which it was added to the National Register of Historic Places. It is currently the home of the Schuylkill County Council for the Arts.

Three

SURVIVING PROHIBITION

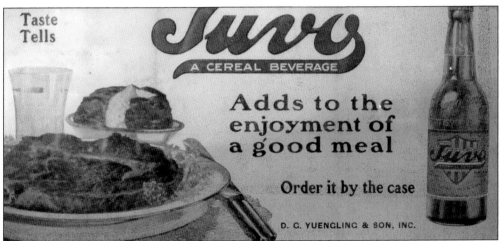

On January 17, 1920, national Prohibition took effect after passage of the 18th Amendment to the Constitution. It was the culmination of a long battle by temperance advocates who wanted alcohol outlawed from society. After that date, the production and sale of beverages containing more than half a percent of alcohol became illegal, with severe consequences for the brewing industry. While many brewers closed their doors, some proved to be more resourceful and survived the next 14 dry years. Yuengling was a survivor, producing nonalcoholic cereal beverages such as Juvo, a cardboard sign for which is shown here. (Courtesy of D.G. Yuengling & Son, Inc.)

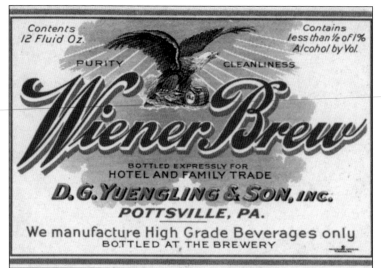

Even prior to the onset of national Prohibition, Yuengling had begun to produce nonalcoholic beverages to sell in regions that had already gone dry. Wiener Brew, a label of which is shown here, was one such beverage. The name "Wiener" means a style of beer that was popular in Vienna, Austria (also known as "Wien").

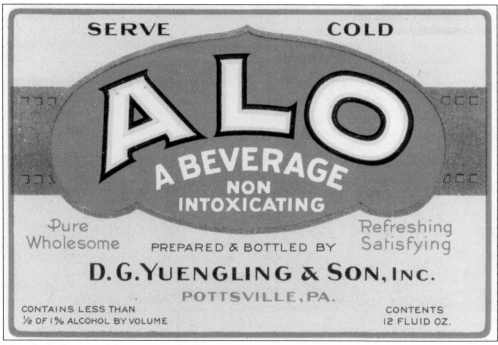

Nonalcoholic cereal beverages, also known as "near beer," were sold by many brewers in the early stages of Prohibition. Juvo and Alo (a label for which is shown here) were two produced by Yuengling during that time. Sales in general were very poor compared to sales of real beer, and by the early 1920s, brewers were beginning to realize that they would likely need to supplement their revenue with other products or businesses in order to survive.

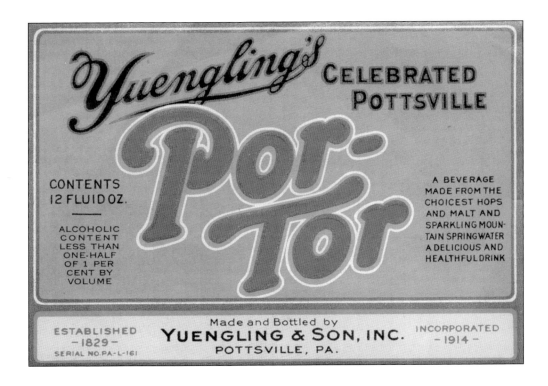

Nonalcoholic porter was a rarity during the Prohibition era, but Yuengling capitalized on the popularity of its Pottsville Porter by making Por-Tor, a dry version of the same. A bottle label for the beverage is shown above, with claims that it is "delicious and healthful." Below is a cardboard sign advertising the brand, which could be sold anywhere, just like other soft drinks. (Below, courtesy of D.G. Yuengling & Son, Inc.)

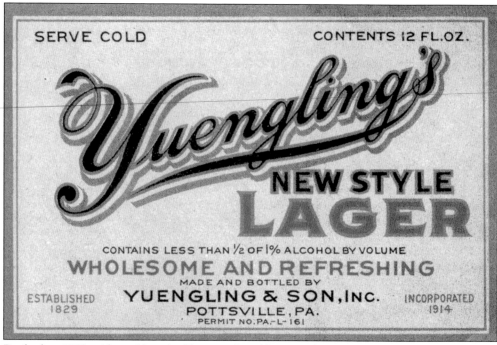

SERVE COLD CONTENTS 12 FL. OZ.

Yuengling's
NEW STYLE
LAGER
CONTAINS LESS THAN ½ OF 1% ALCOHOL BY VOLUME
WHOLESOME AND REFRESHING
MADE AND BOTTLED BY
YUENGLING & SON, INC.
ESTABLISHED POTTSVILLE, PA. INCORPORATED
1829 PERMIT NO. PA.-L-161 1914

By the late 1920s, Alo and Juvo had been replaced by Yuengling's own brand of cereal beverage, known as New Style Lager, a label for which is shown here. Although the word "beer" could not be used to describe the nonalcoholic beverages, there was no restriction on descriptive terms such as "lager" or "pilsner." During this period, the company briefly altered its name, eliminating the "D.G." at the beginning.

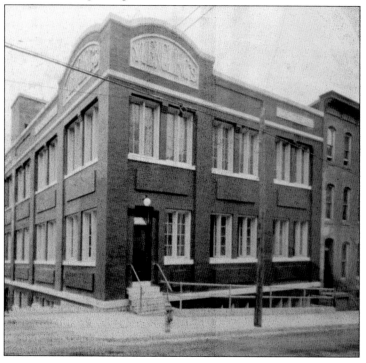

Ultimately, what allowed Yuengling to survive the Prohibition era was not the production of near beer but the production of ice cream. Just as national Prohibition was taking effect in 1920, Yuengling was constructing this new building directly across Mahantongo Street from the old brewhouse. Once completed, it would house the Yuengling Dairy Products Corporation, a full-scale dairy with a focus on the production of ice cream. (Courtesy of D.G. Yuengling & Son, Inc.)

This advertisement was carried in numerous regional newspapers on April 15, 1933, just days after Prohibition's end. Although the Yuengling dairy division had been conceived as a way for the company to cope with Prohibition, the legalization of beer did not mean the end of Yuengling milk and ice cream. Although the creamery produced milk and other dairy products, these were not marketed to the same degree as ice cream, which was the company's primary focus.

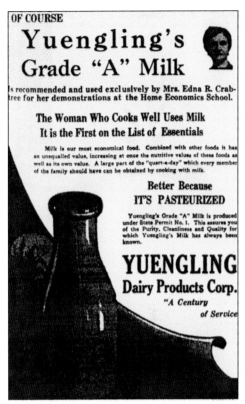

OF COURSE

Yuengling's Grade "A" Milk

Is recommended and used exclusively by Mrs. Edna R. Crabtree for her demonstrations at the Home Economics School.

The Woman Who Cooks Well Uses Milk
It is the First on the List of Essentials

Milk is our most economical food. Combined with other foods it has an unequalled value, increasing at once the nutritive values of these foods as well as its own value. A large part of the "quart-a-day" which every member of the family should have can be obtained by cooking with milk.

Better Because
IT'S PASTEURIZED

Yuengling's Grade "A" Milk is produced under State Permit No. 1. This assures you of the Purity, Cleanliness and Quality for which Yuengling's Milk has always been known.

YUENGLING
Dairy Products Corp.
"A Century of Service"

Tin signs such as this hung in many locations throughout eastern Pennsylvania from the 1920s through the 1980s. The brand was available in most grocery stores, convenience stores, and restaurants in the region.

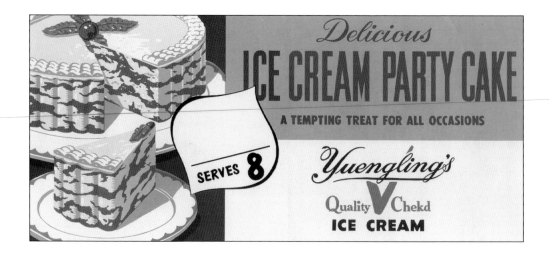

The Yuengling Dairy Products Corporation made a full line of ice cream products in addition to milk. Above is a c. 1960s advertisement for the company's ice cream party cake. Below are two varieties of three-dimensional c. 1950s cardboard grocery store signs for Yuengling boxed ice cream.

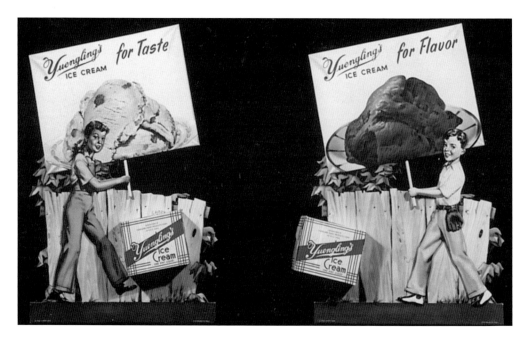

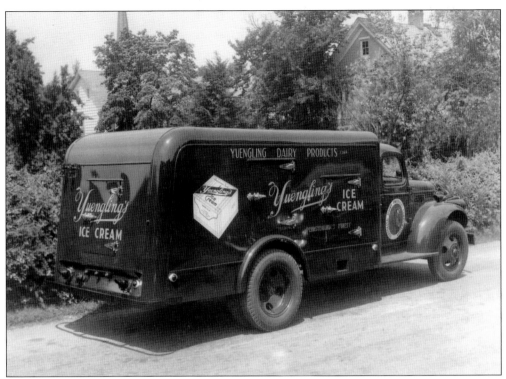

Yuengling ice cream and dairy products were sold throughout eastern Pennsylvania, and the company had a fleet of trucks for deliveries to both stores and homes. Above is a truck from the 1940s; the view below shows a truck from the mid-1960s. (Both, courtesy of D.G. Yuengling & Son, Inc.)

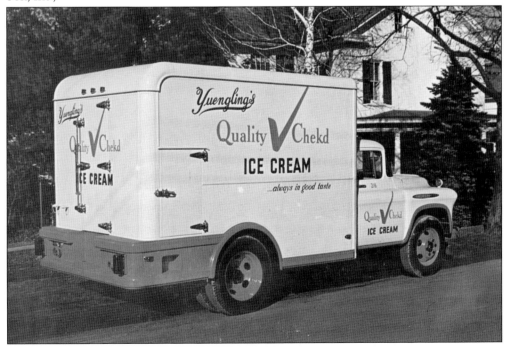

Although the Yuengling dairy produced milk, it became best known for its ice cream, which was advertised heavily in the region. In the early part of the 20th century, ice cream was marketed in many of the same ways that beer had been marketed earlier. This is a serving tray from the 1930s and is one of several different designs used by the company. Some were very ornate, generally showing children eating ice cream.

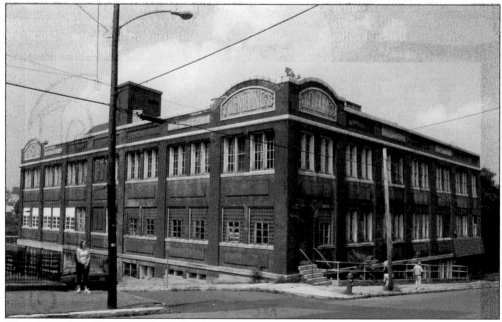

The plant of the Yuengling Dairy Products Corporation, seen here in 2003, was expanded to its current size in the 1930s. The company continued to operate under family management until 1985, when the plant was closed in the face of declining sales. The building continues to stand nearly 30 years after being vacated, albeit in a state of advanced deterioration.

Four

BREWING RETURNS!

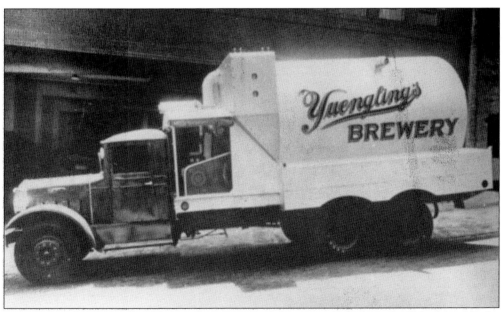

Yuengling Beer returned to the market when Prohibition ended in April 1933, although the first beer was limited to 3.2 percent alcohol. Prohibition was officially repealed on December 5 of that year, after which full-strength beer returned as well. Yuengling had managed to stay in business throughout the Prohibition era and was ready to return to brewing the real thing. This photograph from the mid-1930s shows a 450 bushel-capacity truck delivering malt to the brewery for the brewing process.

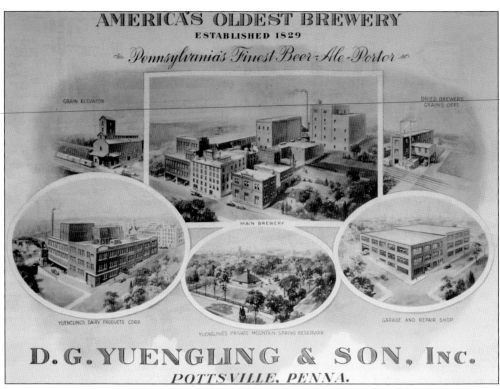

AMERICA'S OLDEST BREWERY
ESTABLISHED 1829
Pennsylvania's Finest Beer-Ale-Porter

GRAIN ELEVATOR

DRIED BREWERS' GRAINS DEPT.

MAIN BREWERY

YUENGLING'S DAIRY PRODUCTS CORP.

YUENGLING'S PRIVATE MOUNTAIN SPRING RESERVOIR

GARAGE AND REPAIR SHOP

D.G. YUENGLING & SON, INC.
POTTSVILLE, PENNA.

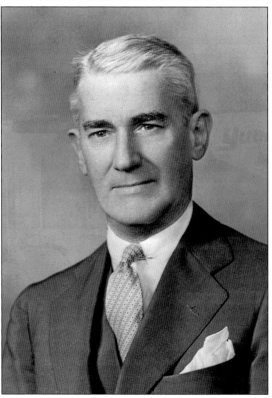

This large sign showed the brewery complex around 1935, after the addition of a new five-story stockhouse at the top of the hill and a new bottling building facing Mahantongo Street. Times had changed, and gone were the ornate, colorful features of the brewery poster, seen on page 33, that was printed 40 years earlier. (Courtesy of D.G. Yuengling & Son, Inc.)

The brewery's success in the first half of the 20th century was largely due to the work of Frank D. Yuengling, son of Frederick and Minna Yuengling. A graduate of Princeton University, he took over operation of the company in 1899 at the age of 22, upon the death of his father. Borrowing a half million dollars, he proceeded to buy out the shares of other family members to consolidate its ownership. Until the debt was paid off, he and his mother lived on $50 a week. Frank continued to oversee the company's operations until his death in 1963. (Courtesy of D.G. Yuengling & Son, Inc.)

At the time of Prohibition's end, Yuengling immediately started production of the Winner and Porter brands of beer, cardboard signs of which are seen at right and below. Yuengling was one of several American brewers that showed gratitude to President Roosevelt for ending Prohibition by sending a truckload of beer to the White House. In Yuengling's case, Winner was the brand sent, although some of the shipment was stolen along the way. (Both, courtesy of D.G. Yuengling & Son, Inc.)

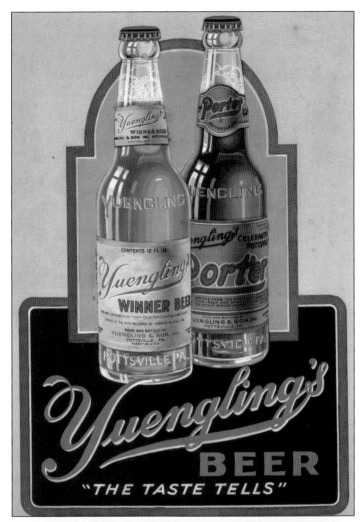

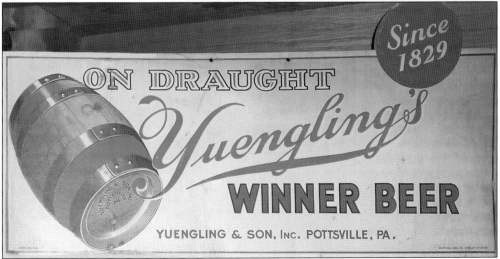

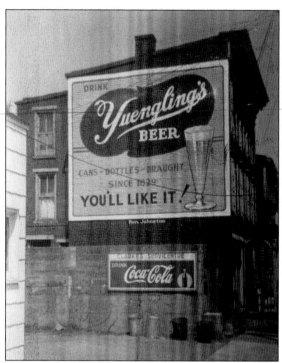

Large outdoor advertisements came in the form of billboards and painted signs on buildings such as this one from the late 1930s. These painted signs had the advantage of longevity; although somewhat faded, some such signs have survived for many years after they were put in place. (Courtesy of D.G. Yuengling & Son, Inc.)

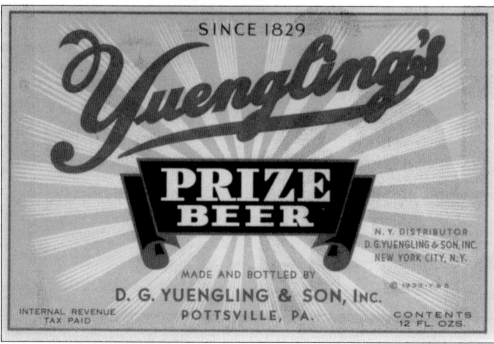

Yuengling Winner Beer was phased out by the mid-1930s in favor of Yuengling Lager, Pilsner, and Prize Beers. The Prize brand, a label for which is shown here, was marketed as a premium brand of higher quality and carried a slightly higher price per bottle. Not meeting the same level of success as the company's other brands, Prize was phased out by 1940. It did return for a few years in the early 1960s, as shown on page 85.

Yuengling Olde Oxford Ale was a pale, English-styled ale that was produced in the 1930s and 1940s. As consumer tastes changed in the post–World War II era, the brand was reformulated as a lighter-bodied brew and renamed as Yuengling Cream Ale. By the late 1950s, the overall market for ale had declined significantly and the brand was discontinued. At right is a cardboard sign for the brand, and below is a tin-over-cardboard sign, both of which would be used in bars and grocery stores. (Both, courtesy of D.G. Yuengling & Son, Inc.)

Newspaper advertising continued to be an effective form of marketing for breweries well into the 1950s. The advertisement at left for Yuengling Olde Oxford Ale was one of several similar advertisements that appeared in regional newspapers in 1938. Yuengling Bock Beer, a bottle label of which is shown below, was also marketed heavily in newspapers. The brand was available for several weeks each year, generally starting around St. Patrick's Day, and remained in production into the early 1960s.

This c. 1940 cardboard sign advertised Yuengling's half-gallon (64 ounce) bottles, which were available from the mid-1930s through the onset of World War II. (Courtesy of D.G. Yuengling & Son, Inc.)

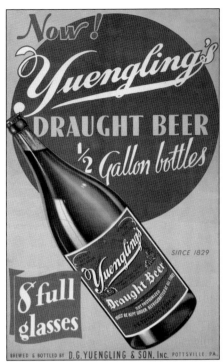

This photograph, taken around the time of Prohibition's end, shows Yuengling's neighbor to the east, St. Patrick's Catholic Church. Although the current building's construction began in 1891, the church's origin was actually in 1827, four years before the brewery was constructed at its current site. The two structures stand just inches apart. (Courtesy of D.G. Yuengling & Son, Inc.)

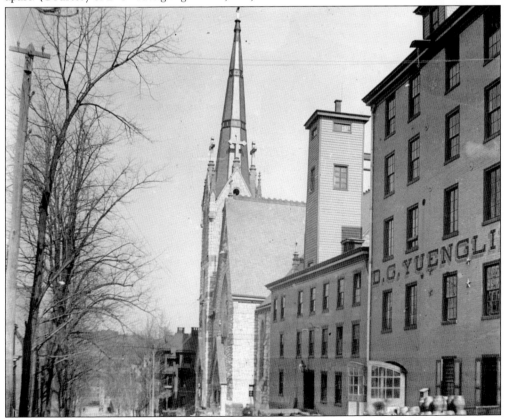

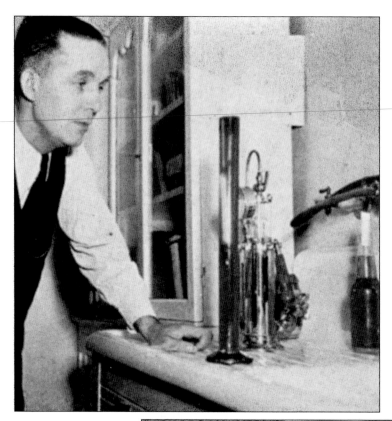

This photograph is from the March 1939 edition of *Modern Brewery Age*, a brewing industry magazine. It shows Yuengling master brewer Joseph Bausback in his small laboratory, adjacent to his office. Today, the office remains intact, as does the same small laboratory, next to the plant's gift shop and museum. Bausback was a native German who had moved to the United States in 1910 and joined Yuengling during Prohibition. He was the company's master brewer until his death in the late 1940s.

Serving trays continued to be a common form of advertising after Prohibition's end, and Yuengling produced them with several different designs. This particular design featured the image of a young lady whose picture would be used in numerous other advertisements, including some retro advertisements used today. (Courtesy of D.G. Yuengling & Son, Inc.)

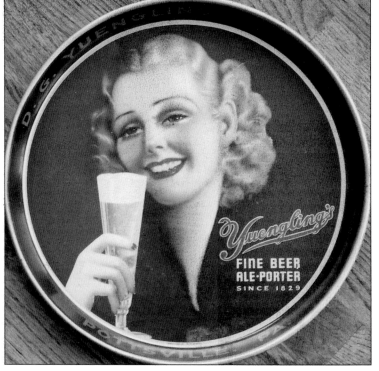

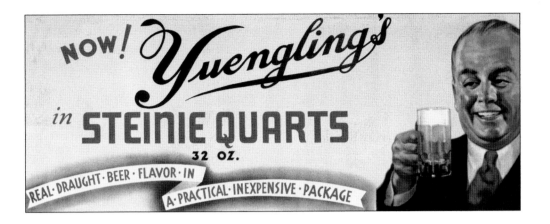

Quart bottles were marketed heavily during the early days of World War II as a way to use fewer bottle caps, since metal was being rationed for the war effort. While Yuengling Beer had previously been sold in quart-sized cans as well, can production was discontinued in 1942 due to metal restrictions (can production would return in 1947). Above is a cardboard sign advertising the larger bottles. Below is a photograph taken on Memorial Day 1942 featuring, from left to right, John Fallon, Mary Monaghan, Arlene Sallade, and Homer Koch, all of whom are drinking Yuengling Beer out of quart bottles. (Both, courtesy of D.G. Yuengling & Son, Inc.)

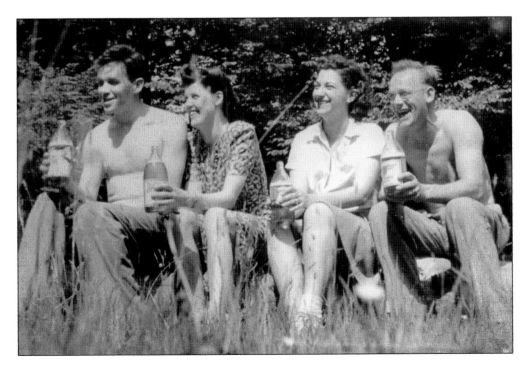

This cardboard sign from the late 1930s may be politically incorrect by today's standards, but such forms of advertising were not uncommon in that era. (Courtesy of D.G. Yuengling & Son, Inc.)

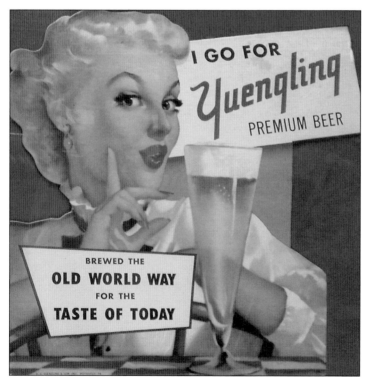

Attractive women continued to appear in advertising by many brewers through the 1950s, and Yuengling was no exception. This cardboard sign from the early 1950s mentioned "The Taste of Today," a reference to the lighter style of beer that had become popular in the early postwar period. Using less malt, these modern beers were less filling and were preferred by brewers since the typical patron could drink a six-pack at a time instead of feeling full after one or two beers as with the older, heavier, more traditional brews. (Courtesy of D.G. Yuengling & Son, Inc.)

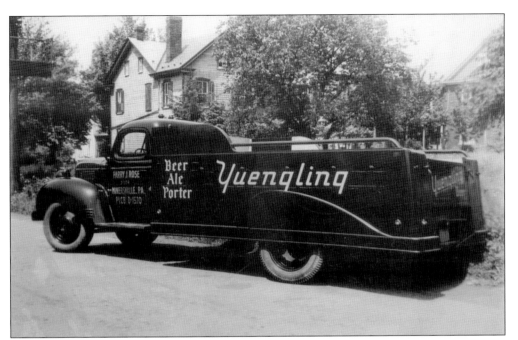

Early delivery trucks came in numerous sizes and designs. The majority of trucks that delivered Yuengling Beer were used for short distance sales, such as this one from the late 1940s that was stationed in Minersville, just four miles west of Pottsville. (Courtesy of D.G. Yuengling & Son, Inc.)

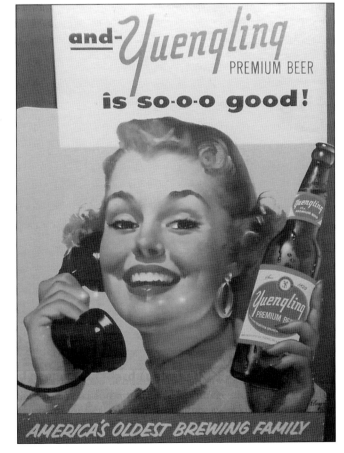

Another pretty lady appears in this cardboard sign from the late 1950s. This is one of the earliest signs to reference Yuengling as America's oldest brewery, which became the case in 1956. (Courtesy of D.G. Yuengling & Son, Inc.)

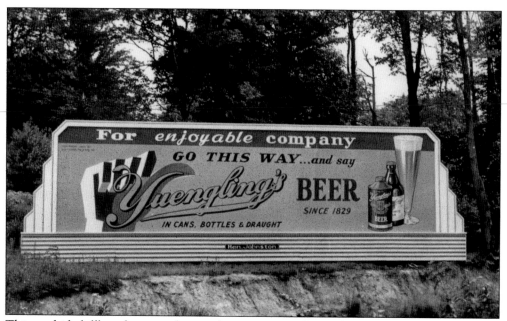

This roadside billboard appeared somewhere in eastern Pennsylvania in 1940 and featured a bottle as well as a cap-sealed, cone-topped can. Yuengling had recently begun using these for the packaging of its premium beer. The cap-sealed cans could be filled on existing bottling lines, which saved the company the cost of an expensive, separate canning line. (Courtesy of D.G. Yuengling & Son, Inc.)

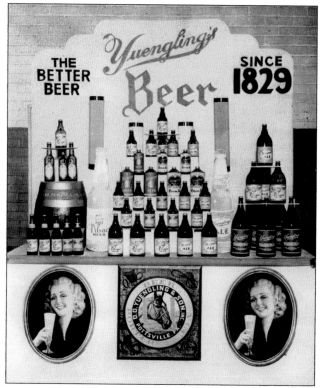

This c. 1940 promotional display shows all of the company's available packaging at the time, including quart-sized cap-sealed cans, which were available on a somewhat limited basis. Also seen here are the more common quart bottles and the short-lived half-gallon bottles. (Courtesy of D.G. Yuengling & Son, Inc.)

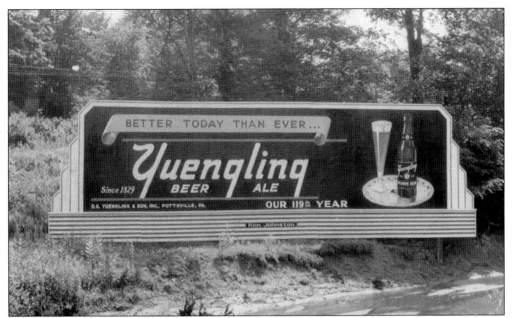

This roadside billboard appeared in 1948 and features one of the first mentions of the brewery's age in years. The prewar billboard shown on the previous page only mentioned that the company had been in business since 1829. Billboards became an increasingly effective form of marketing after World War II as automobile ownership soared and Americans took to the road. (Courtesy of D.G. Yuengling & Son, Inc.)

Through the years, Yuengling used advertising signs that were made of paper, cardboard, wood, tin, aluminum, and glass. Each material had certain advantages depending on the visual effect desired. This glass sign was particularly striking in that it had a mirrored background, with the design superimposed in green and white, making it effective in a low-light setting such as a bar. Similar signs were also used for the company's beer and porter.

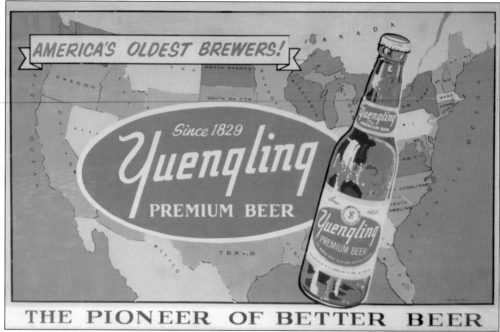

The Boston Beer Company opened for business in 1828, one year before Yuengling, and was widely considered to be the nation's oldest brewery until its closing in 1956. After that, Yuengling rightly took that title for itself and has used it in nearly all of its advertising since then. This colorful cardboard sign from the late 1950s is a good example of that. (Courtesy of D.G. Yuengling & Son, Inc.)

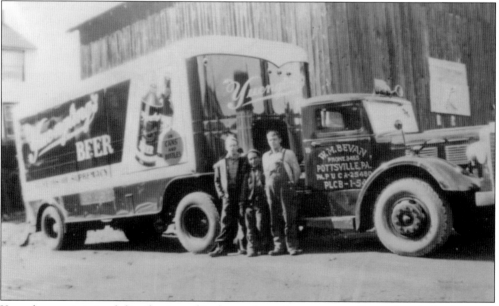

Yuengling maintained distribution of its beers throughout eastern Pennsylvania in the post-Prohibition era. Larger semitrailer trucks became available in the 1930s, allowing the company to send large loads to more distant destinations with greater ease. This truck was used by a Pottsville distributor and is shown around 1940. (Courtesy of D.G. Yuengling & Son, Inc.)

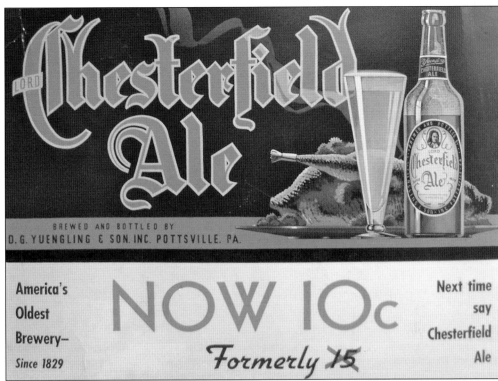

Lord Chesterfield Ale is a robust pale or blond ale, somewhat more full bodied than Yuengling Olde Oxford Ale was, and more reminiscent of the company's pre-Prohibition ales. With 5.6 percent alcohol by volume, it is more potent than the company's other brands. Described as a Canadian-style ale, it went into production soon after Prohibition's repeal and has remained available to the present day. As the company's only ale product, it has retained its own loyal following. Above is a cardboard display used in stores, while below is a promotional trade card used by the company in the 1930s. (Both, courtesy of D.G. Yuengling & Son, Inc.)

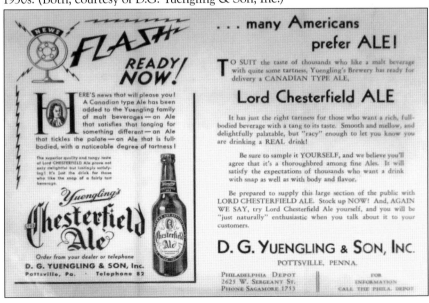

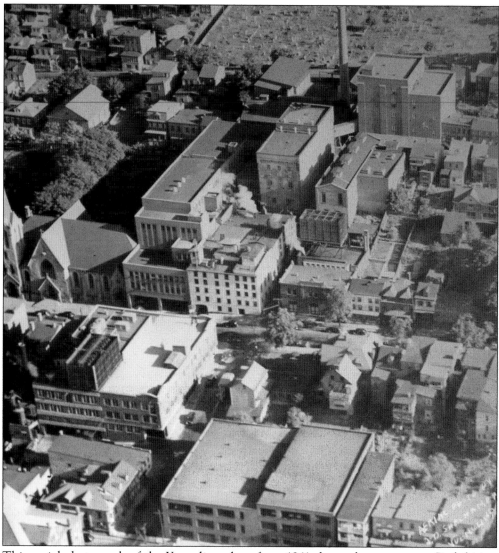

This aerial photograph of the Yuengling plant from 1941 shows the recent post-Prohibition additions and can be contrasted to the lithograph on page 33, which shows the plant from the same direction 40 years earlier. The company garage and ice cream plant are in the foreground, while the new five-story stockhouse at the top of the hill is in the rear, along with the company's power plant. (Courtesy of D.G. Yuengling & Son, Inc.).

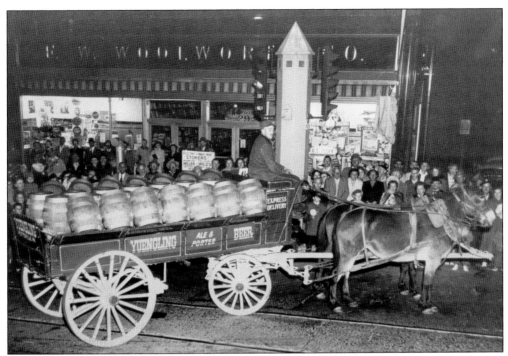

These images both show a horse-drawn wagon loaded with barrels of Yuengling Beer. However, the scene is not from 1900 but from the 1940s, and the wagon is taking part in a parade. Many brewers temporarily reverted to horse-drawn delivery wagons for local sales during World War II, due to gas rationing. (Both, courtesy of D.G. Yuengling & Son, Inc.)

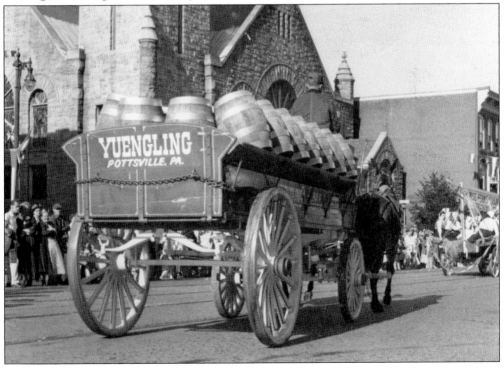

Mary Cooney owned the Hotel Hampton on Eighteenth Street in Philadelphia, and she is seen here posing in front of the building c. 1940. Behind her is a large, lighted, two-sided, hanging sign for Yuengling Beer that was sold nearby. (Courtesy of D.G. Yuengling & Son, Inc., and the Boland family.)

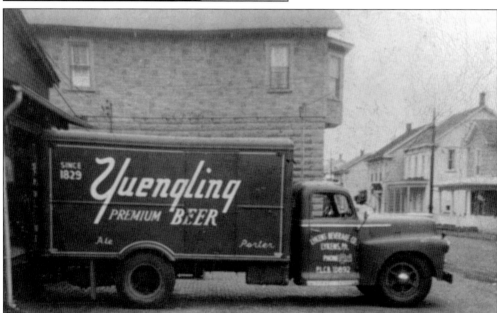

This delivery truck is shown c. 1950 in Lykens, Pennsylvania, 30 miles west of Pottsville. Yuengling had distributors throughout eastern Pennsylvania, which allowed the brand to compete effectively with the region's numerous other breweries that still remained in operation at that time.

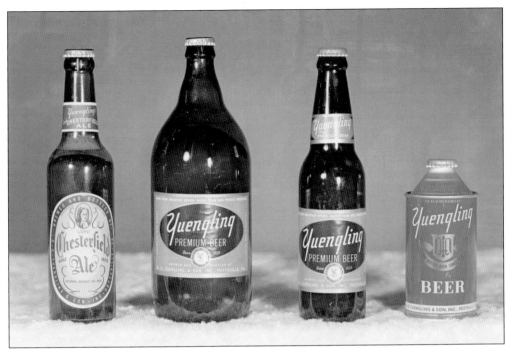

This promotional image shows a limited lineup of Yuengling products in 1955. Compare this image to the one from 15 years earlier on page 68, where far more styles and packaging were available. Chesterfield Ale was available only in bottles, while Yuengling Premium Beer was available in bottles and cans. Not shown here were Yuengling Porter and Cream Ale and the quart-sized can, still available on a more limited basis. (Courtesy of D.G. Yuengling & Son, Inc.)

Beer and sports have gone together for more than a century, and Yuengling was one of several brewers that sponsored Philadelphia sports teams in the 1950s. This cardboard sign displayed the 1952 schedule for the Eagles of the National Football League and left space at the top for bartenders to write in the score of the day's game in chalk. (Courtesy of D.G. Yuengling & Son, Inc.)

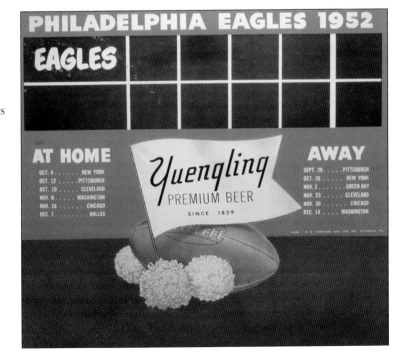

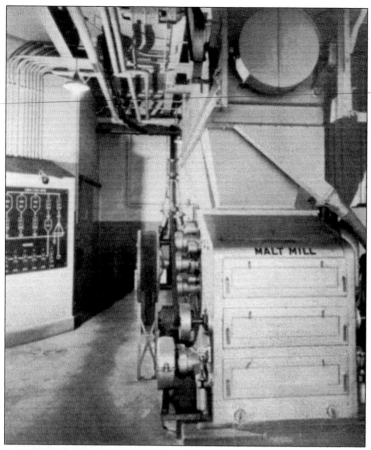

These photographs and those on the following two pages are taken from a Yuengling promotional brochure that was made in 1954 for the company's 125th anniversary, showing several scenes inside the plant. At left is a view of the malt mill, where grain is crushed at the beginning of the brewing process. Here, "all foreign materials other than malt are automatically separated, thus assuring the finest and purest malt for each brew." Below is the copper brew kettle, and in the background is a new 600-barrel lauter tun. (Both, courtesy of D.G. Yuengling & Son, Inc.)

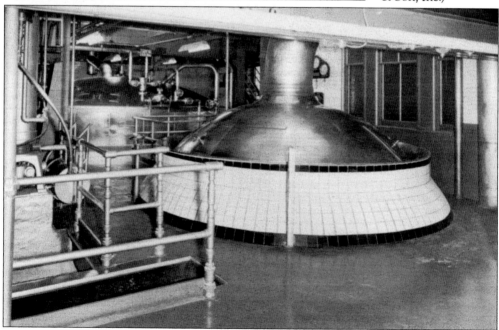

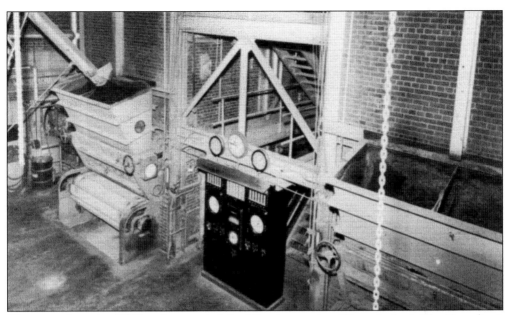

This image from the 1954 brochure carried the following caption: "From the beginning Yuengling's has taken advantage of the economy and efficiency of hard Pennsylvania anthracite. Today's boiler house is equipped with the most modern automatic stokers, using the newer, high-efficiency anthracite from nearby collieries." (Courtesy of D.G. Yuengling & Son, Inc.)

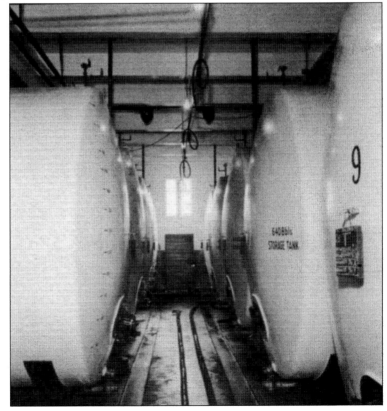

Another image from the 1954 brochure, this shows the interior of the Yuengling stock house, with the following caption: "A far cry from the old underground tunnel is this storage cellar, where great modern tanks like this are used to hold the brew until the master brewer says it is 'ready'." Each tank shown here held 640 barrels—or nearly 20,000 gallons—of beer. (Courtesy of D.G. Yuengling & Son, Inc.)

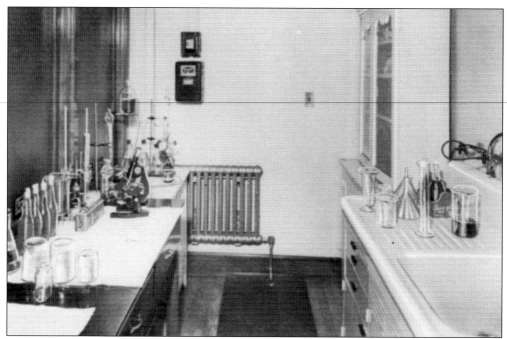

Also from the 1954 brochure, this image of the brewery laboratory came with this caption: "The brewmasters of today accept with appreciation the added assist from modern control laboratories. Our continuous testing is a routine-but important-feature of keeping the quality of Yuengling's uniform." Although much more cluttered today, the laboratory still exists largely as shown here. (Courtesy of D.G. Yuengling & Son, Inc.)

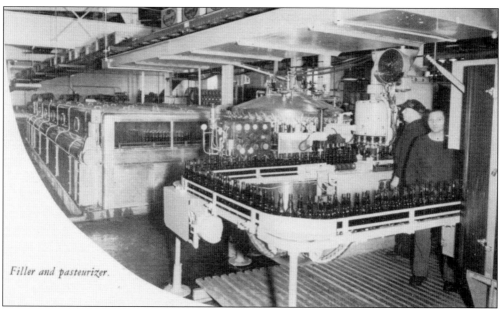

Filler and pasteurizer.

This final view from the 1954 brochure shows the interior of the bottling building, where bottles are being filled with beer before entering the pasteurizer. This process of heating the bottles helps to prevent spoilage while they are on store shelves. (Courtesy of D.G. Yuengling & Son, Inc.)

Yuengling Porter returned to production after Prohibition's end, in draft as well as 12- and 8-ounce "Brownie" bottles, a label of which is shown here. After World War II, America's taste in beer began to shift toward lighter styles, and most brewers ended the production of porter. Yuengling bucked that trend, however, continuing to produce its porter to the present day. This would prove to be fortuitous to the company's fortunes in the late 1980s, when Yuengling Porter was used to create the highly successful Black & Tan brand.

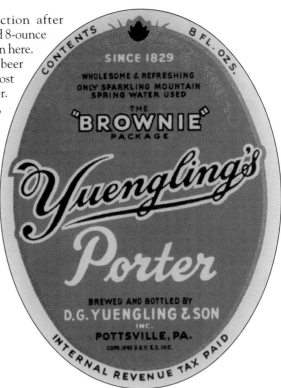

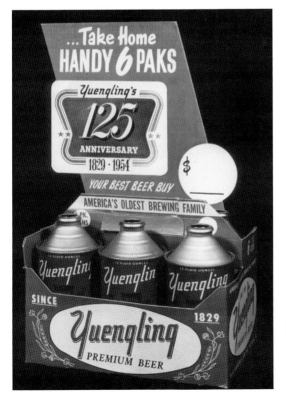

Six-packs in the mid-1950s were more ornate than today, with colorful cardboard holders instead of clear plastic rings holding cans together. At the time of Yuengling's 125th anniversary, the company was still utilizing cap-sealed cans. (Courtesy of D.G. Yuengling & Son, Inc.)

79

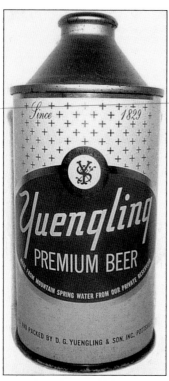

By 1960, the Yuengling Beer label had been redesigned with a white background and a simple red label, typical of the era. The era of cap-sealed cans was about to come to an end, however, as they were phased out shortly after this in favor of flat-topped cans, which could be stacked more efficiently in stores. (Courtesy of D.G. Yuengling & Son, Inc.)

Photographing a brewery's employees was a relatively common occurrence in the pre-Prohibition era, but by the late 1950s, it had become a rather rare one. This photograph from that era shows 30 of Yuengling's employees posing with a young Richard Yuengling (second row, fourth from right) in front of the company office building. (Courtesy of D.G. Yuengling & Son, Inc.)

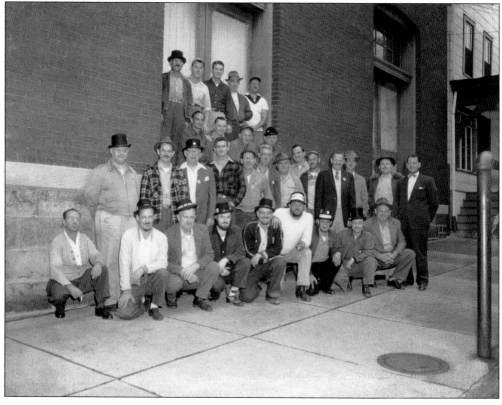

Five

HANGING ON

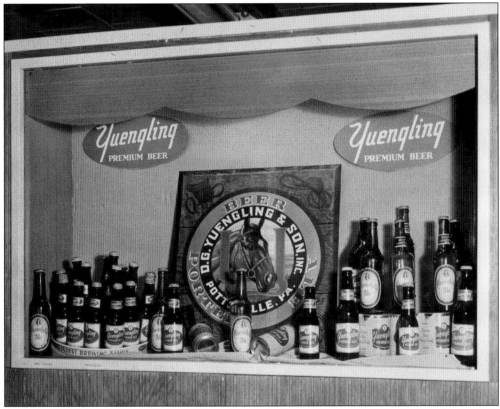

By the early 1960s, Yuengling was largely treading water from a business perspective. Modernizations over the years had increased the plant's annual capacity to 200,000 barrels, although actual sales were typically less than half that number. As other longtime brewers in the region slowly dwindled in number, victims of an increasingly competitive industry, Yuengling entered a lengthy period when its long-term fate appeared uncertain. Above is a display, c. 1960, showing the company's products at the time. Also present is the same tin sign previously seen on page 68. Featuring a horse, the same design appeared on a company serving tray. (Courtesy of D.G. Yuengling & Son, Inc.)

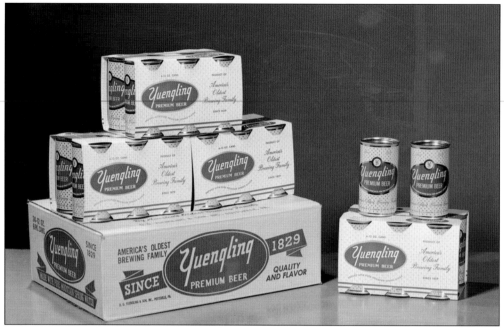

Draft beer sales only accounted for 20 percent of Yuengling's business by 1960. Canned beer sales continued to slowly improve over the years, and within another decade, they would finally top the sales of beer in bottles. This image shows the company's flat-topped cans that had recently replaced the cone-topped versions. These were preferable to retailers by being easier to stack and display in cases and six-pack holders. (Courtesy of D.G. Yuengling & Son, Inc.)

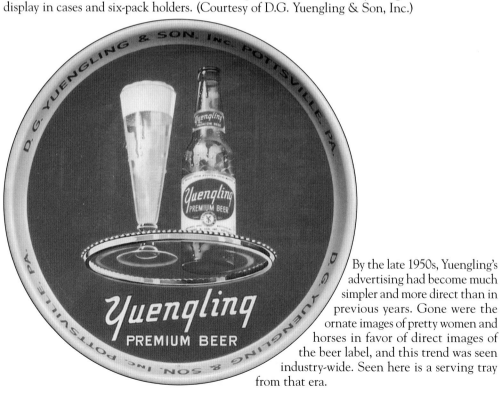

By the late 1950s, Yuengling's advertising had become much simpler and more direct than in previous years. Gone were the ornate images of pretty women and horses in favor of direct images of the beer label, and this trend was seen industry-wide. Seen here is a serving tray from that era.

Born in 1915, Richard L. Yuengling Sr. guided the brewery's operations through a very difficult period. Trained extensively in the brewing field, he and brother Dohrman assumed control of the company upon the death of their father, Frank, in 1963. Initially handling marketing and sales, Richard took control of the entire company after Dohrman's death in 1971. Watching uneasily as other small brewers in eastern Pennsylvania closed their doors in the 1960s and 1970s, he was able to maintain the Yuengling brand's loyal customer base into the mid-1980s.

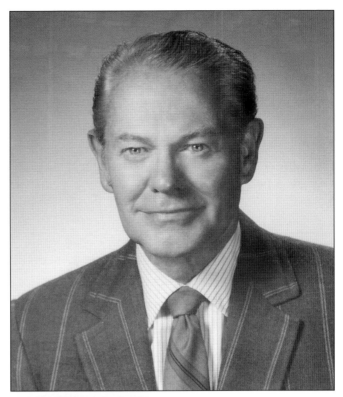

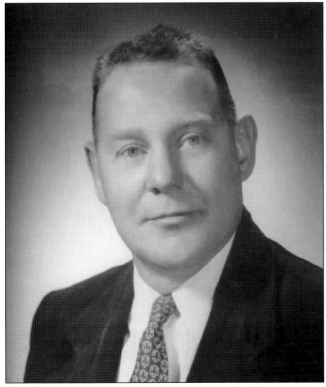

Frank Dohrman Yuengling Jr., who went by the name Dohrman, was the older brother of Richard. Born in 1913, he was also trained extensively in the brewing business and assumed the role of plant manager, overseeing brewing operations for the company. The brothers operated the company together until Dohrman's premature death in 1971 at the age of 58. (Courtesy of D.G. Yuengling & Son, Inc.)

While the company's 135th anniversary was not one of its major milestones, the occasion was still noted on this small metal ashtray in 1964. One of four different designs produced, this one shows a generic hunting scene.

This newspaper advertisement from 1965 focused on the historic aspect of the company, showing Dohrman Yuengling dressed up in 19th-century attire in contrast to his nephew Dick Yuengling, who was still a teenager. Twenty years later, Dick would assume the company's management himself and bring it to a level of success that was unthinkable in 1965. (Courtesy of D.G. Yuengling & Son, Inc.)

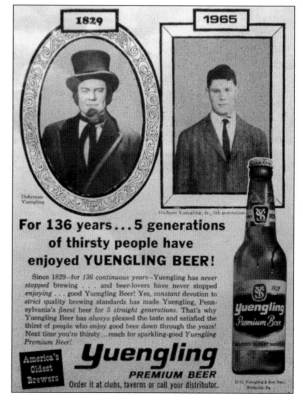

The original Yuengling Prize Beer had been discontinued around the onset of World War II. However, the Prize name returned nearly two decades later, in the form of a low-cost bargain beer that was packaged by Yuengling over several years for the regional Food Fair supermarket chain. Seen here is a can of that brand c. 1962.

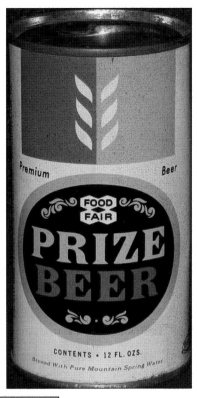

By the 1960s, point-of-sale advertising (signs used in bars or beer stores) had become very simple and inexpensive to produce. Long gone were the ornate features of previous advertisements, and long gone were fragile signs made of glass. This simple yet effective lighted plastic clock was used in the late 1960s and 1970s.

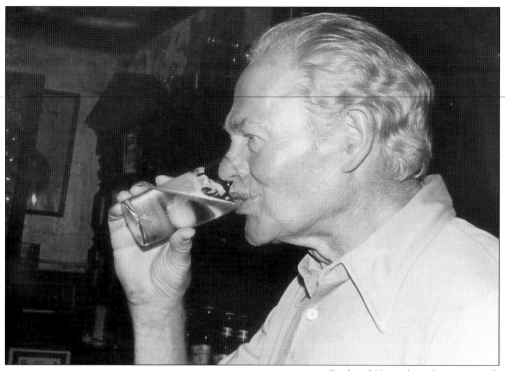

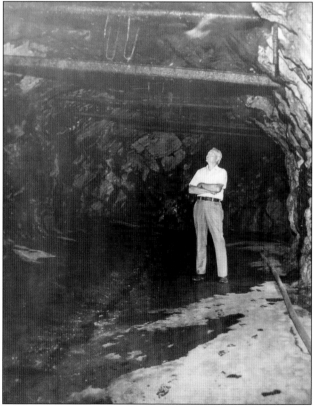

Richard Yuengling Sr. remained in charge of the company throughout this era and was a very hands-on owner. In addition to overseeing all operations of the plant, it was not unusual for him to take visitors on tours of the historic brewery or to join them in the rathskeller for a beer, as shown above. At left, he is seen in one of the underground tunnels c. 1980. (Both, courtesy of D.G. Yuengling & Son, Inc.)

Yuengling's 150th anniversary in 1979 was a major milestone for the company, and to celebrate the event, the company redesigned some of its bottle labels and cans to feature the earliest drawing of the brewery from the 1840s. Labels and cans featuring the brewery's image continued to appear over the following decade.

Yuengling Old German Beer was the company's discount brand, produced from the mid-1930s through the late 1980s. Selling for somewhat less than Yuengling's other brands, it was popular with college students and people of lesser means. It was sold only in bottles, a label for which is shown here, and was characterized as a slightly sweet lager.

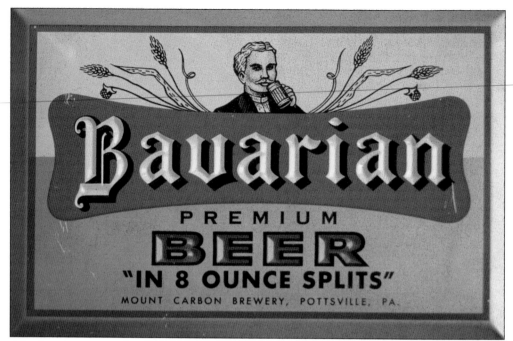

After brewing returned in 1933, Yuengling's only local competition came from the Mount Carbon Brewery, one mile away at 716 South Centre Street. With origins dating back to the mid-19th century, the company remained in business until 1976 producing its Bavarian brand of beer, which was distributed over a several county area around Pottsville. After Mount Carbon closed, Yuengling acquired the Bavarian brand, continuing to produce it into the late 1980s. Above is a tin-over-cardboard sign used by Mount Carbon in the 1960s; below is a cardboard sign used after the brand was acquired by Yuengling, which was still contractually obligated to use the Mount Carbon name. (Both, courtesy of D.G. Yuengling & Son, Inc.)

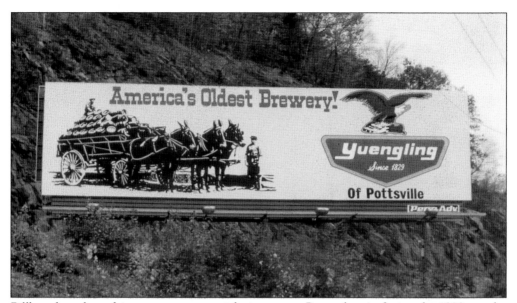

Billboards such as this were a common sight in eastern Pennsylvania during the 1980s, as the company tried to maintain its relatively small market share against the rising tide of competition from national brands. The company's broad use of its title as America's Oldest Brewery in marketing clearly gave it an edge over the shrinking number of Pennsylvania-based brewers. (Courtesy of D.G. Yuengling & Son, Inc.)

Ray Norbert, shown here, was the Yuengling master brewer from 1960 to 1999 and spent an amazing 57 years working for the brewery overall. It was Ray who devised the formula for Yuengling Lager Beer, which remains the company's biggest selling brand today. He also formulated the Black & Tan brand and Yuengling Premium Light Beer. (Courtesy of D.G. Yuengling & Son, Inc.)

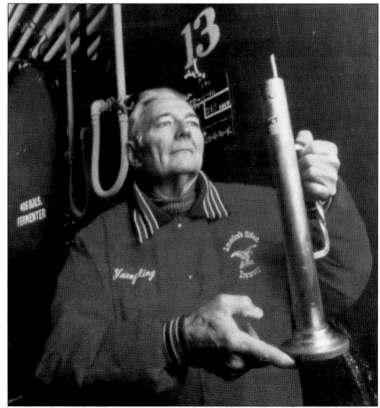

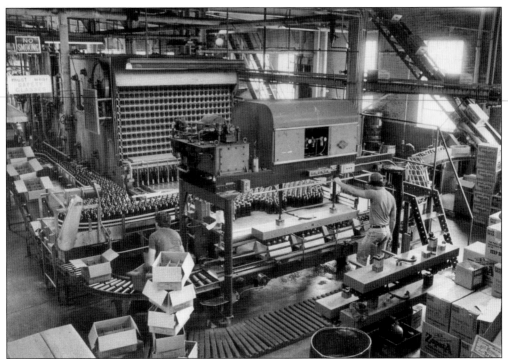

This view from 1983 shows the interior of the bottling building, with the huge bottle-washing machine in the background. In the foreground are bottles being gathered mechanically to be placed in cartons of 24. By this time, limited manpower was required to maintain and oversee the equipment. (Courtesy of D.G. Yuengling & Son, Inc.)

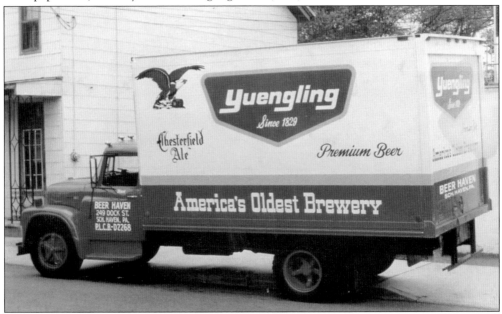

In the early 1980s, local sales of Yuengling Beer were still being made with small trucks such as this one that was stationed in the town of Schuylkill Haven, five miles south of Pottsville. (Courtesy of D.G. Yuengling & Son, Inc.)

In 1963, Yuengling modified its company logo and began to use the red pentagonal label shown here on its cans and bottles. This design would identify the company's beer well into the 1980s. Around the same time that this change took place, the company began to use the newly invented aluminum zip tabs, allowing consumers to open the can without the use of a church-key type opener.

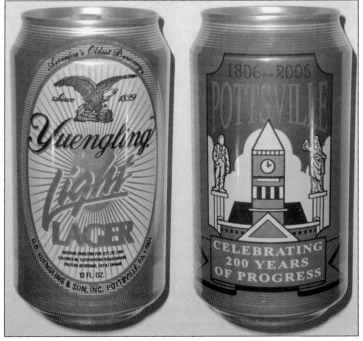

Over a roughly 30-year period beginning in the late 1970s, Yuengling began producing commemorative cans that were tailored for collectors or for special events in the region. More than 50 different designs of these cans were produced over the years, such as this one from 2006, celebrating Pottsville's bicentennial.

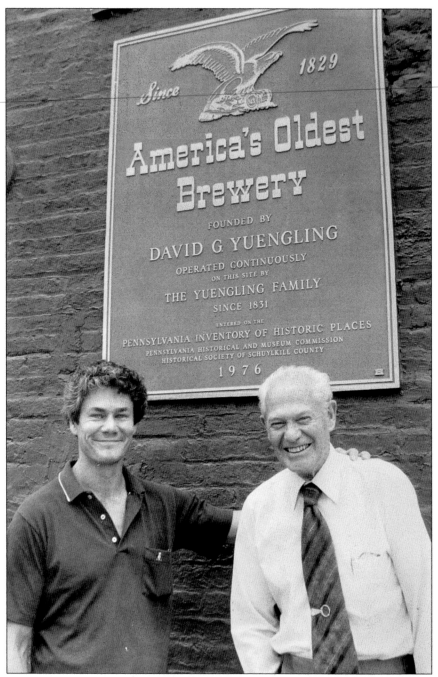

This c. 1985 image shows a symbolic "changing of the guard," with Richard Yuengling Sr. (right) and his son Dick. It was in this year that Dick took over management of the company, representing the fifth generation of the family to do so. His father had begun to suffer the effects of Alzheimer's disease but remained in the area after retirement until his death in 1999. The men are standing in front of the old brewhouse, which had been declared as a Pennsylvania historic site in 1976 and was added to the National Register of Historic Places 10 years later. The plaque on the wall behind them remains in place today. (Courtesy of D.G. Yuengling & Son, Inc.)

Six

AMERICA'S

OLDEST BREWERY

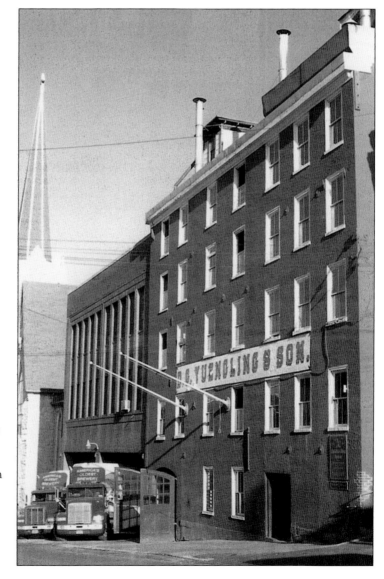

This postcard view of the Yuengling brewery at Fifth and Mahantongo Streets was taken in the 1990s and shows two large trucks parked at the loading dock. The current brewhouse was completed as it appears now in the 1870s, making it more than 140 years old. Although the brewery is old and outdated in some ways, the marketing value of having such a historic plant has proven to be immeasurable.

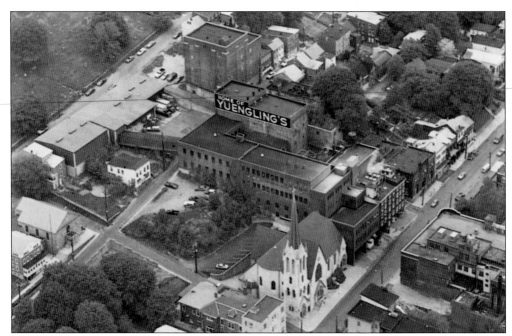

This postcard shows an aerial view of the Yuengling brewery c. 1990. It still retains the same general layout today. The view from above does not sufficiently indicate the steepness of the hill into which the plant is built.

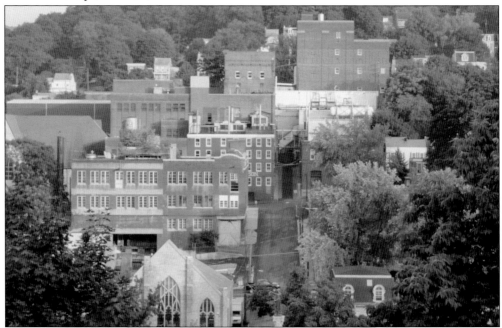

This view of the brewery from a distance gives one a sense of how the various buildings are constructed on different levels. The location was chosen in 1831 out of necessity because of the hillside, allowing storage caves to be dug underground. Today, however, a flat surface is preferable to maximize efficiency of operation, as is seen with the modern Mill Creek brewery two miles away.

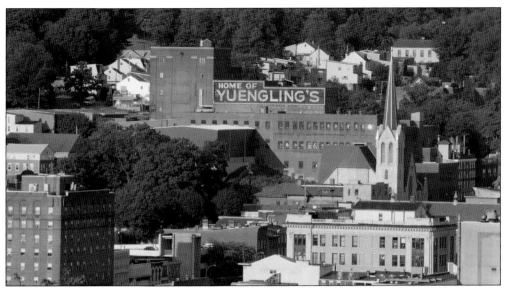

This view of the brewery complex from the far side of Pottsville is essentially the first image that visitors have as they enter the city. The prominent Yuengling name is visible throughout the downtown area due to its elevation on the side of Sharp Mountain, seen in the background. The tall spire of St. Patrick's Catholic Church next door is also visible. (Courtesy of D.G. Yuengling & Son, Inc.)

The primary Yuengling company offices are housed in this building, across Fifth Street from the brewery. Constructed in the early 20th century, it replaced an earlier four-story building, known as "the Old Homestead," that had served as the Yuengling family home as well as housing the company offices.

Constructed shortly after Prohibition's end on the site of the original brewery building from 1831, the Yuengling bottling plant stands on the east side of the brewhouse. Although architecturally unremarkable, the building is now 80 years old, adding to the historic significance of the site.

Also built shortly after Prohibition's end, the five-story stock house stands at the top of the hill on the south side of the Yuengling brewery complex. As such, it is the most visible portion of the plant from a distance. The building contains steel tanks for fermenting and storing thousands of barrels of beer at a time.

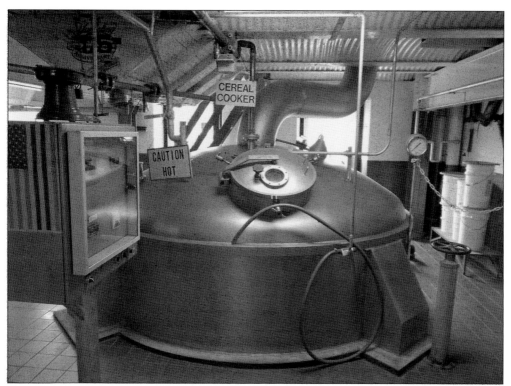

The original Yuengling brewery's equipment was upgraded and modernized in the 1980s and 1990s. Above is the stainless steel cereal cooker, installed in 1985. Here, corn grits and malted barley are cooked and liquefied at the start of the brewing process. After this, the mix continues to the mash tun and then to the lauter tun where the liquid, known as wort, is extracted and pumped out through the copper sink shown below. It then proceeds to the brew kettle.

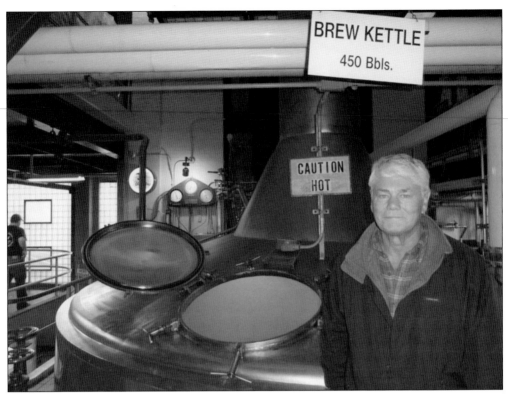

Above, company president Dick Yuengling poses in front of the brew kettle, with its capacity of 450 barrels. It is here that hops are added to the wort for flavoring and the mix is cooked further. The original copper brew kettle was replaced with this stainless steel one in the 1980s. Below is a view inside the huge brew kettle (Above, courtesy of D.G. Yuengling & Son, Inc.)

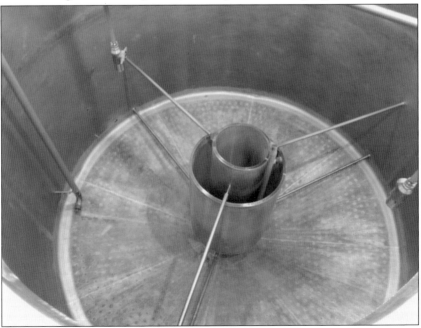

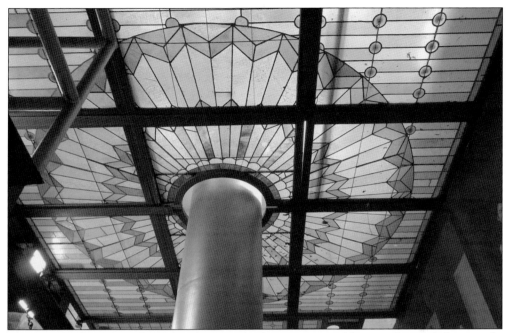

The most focal point inside the brewhouse is this large, century-old series of stained-glass panels. Suspended one story above the brew kettle, their purpose is to prevent glare from the skylight above from reflecting off the vat. Skylights or large ornate cupolas were common features of early breweries as a way to allow heat from the brewing process to escape the building.

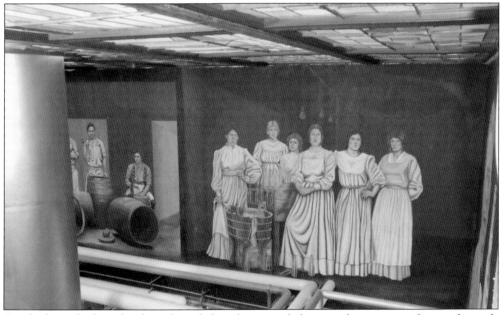

Overlooking the brew kettle and just below the stained glass panels is a series of painted murals depicting various activities inside the brewery a century earlier. This image shows women taking part in the process of washing bottles for reuse. A key point is that the work was not enjoyable, reflected in the fact that none of them are smiling. To the left is an image of men working in the brewery's barrel shop.

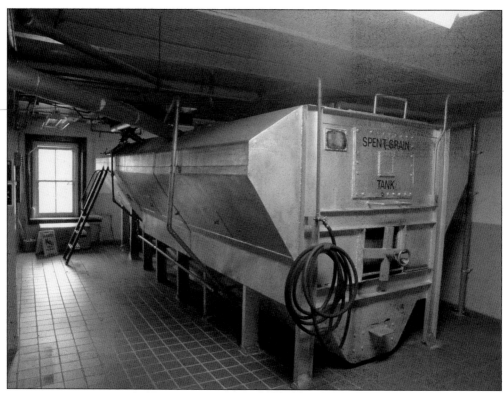

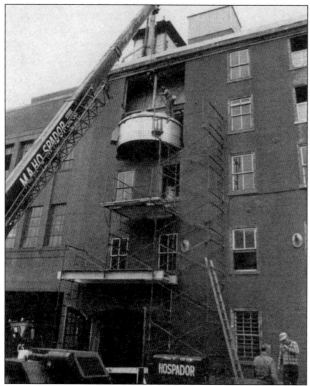

A great deal of solid material remains after the brewing process takes place. Known as "spent grain," this material consists largely of grain husks and other residue, and it is transferred to this tank before being removed from the brewery. Spent grain still has nutritional value and can be used for animal feed, fertilizer, and other purposes.

Installing new equipment in a century-old building can present many challenges. Here, the new cereal cooker was being installed in 1985 as part of an overall upgrade of the brewing equipment. Since the brewing process largely takes place on the building's upper floors, a crane was required to lift the equipment into place, while sections of the building's outer walls were temporarily removed. (Courtesy of D.G. Yuengling & Son, Inc.)

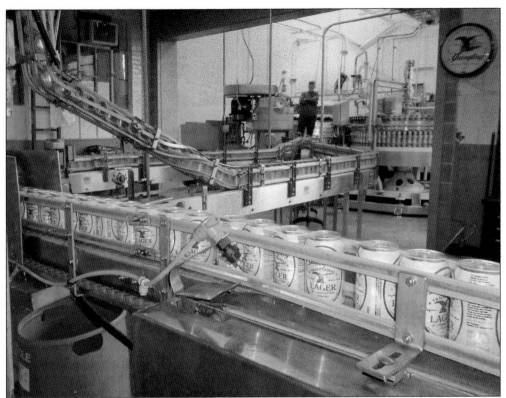

The canning line shown here is a wonder of mechanization. Empty aluminum cans move down the conveyor from above, headed for the filling machine seen in the background. After being filled, their lids are attached, sealing the can. This all happens in a matter of seconds, and thousands of these cans pass through the process daily before being pasteurized and packed into cases for shipping.

After the boiled wort has left the brew kettle, yeast is added and the mix is allowed to ferment, after which time it can truly be called beer. It is then aged before being sent to the bottling department to be packaged in bottles, cans, and barrels. This machine can fill thousands of bottles every hour on a typical day.

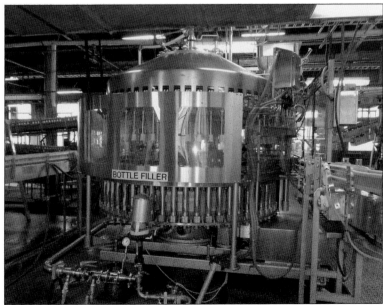

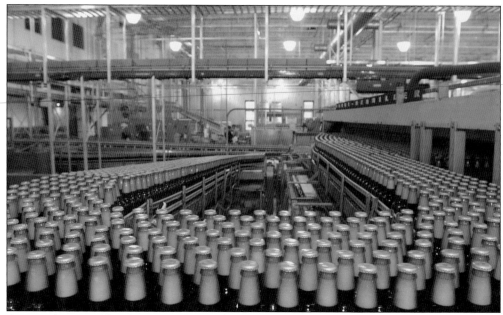

A virtual army of bottles, recently filled and capped, moves along the conveyor inside the Yuengling bottling building, soon to be pasteurized and then placed into six-packs. (Courtesy of D.G. Yuengling & Son, Inc.)

Filled bottles are packed into empty cardboard cartons, 24 at a time, by this machine. Similar machines pack bottles into smaller cartons of 6 or 12 before they all head to the warehouse for storage before being shipped. (Courtesy of D.G. Yuengling & Son, Inc.)

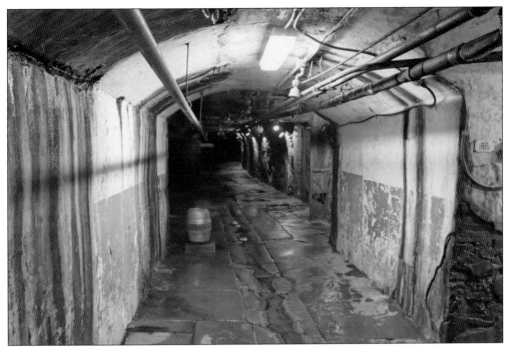

The Yuengling brewery tour includes a descent into the extensive series of caves below the plant, dug by hand in the mid-1800s. The section shown above, lined with concrete, is directly below the brewhouse and leads into the older section, shown below, which is still lined with rock as it was 160 years ago. The caves provided a constant cool temperature for aging the beer, and they remain cool and very humid today. The caves were rendered obsolete once mechanical refrigeration became available in the late 1800s.

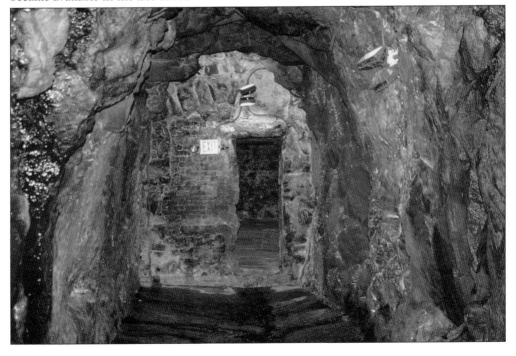

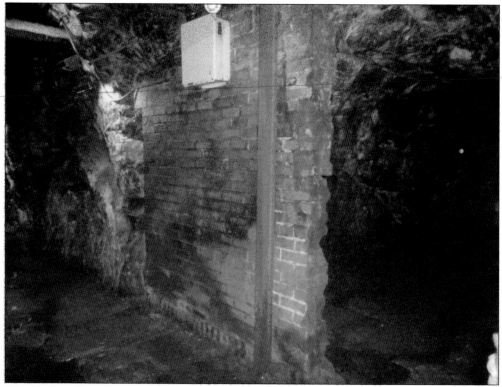

This brick wall was constructed by federal agents in the early days of Prohibition to prevent the underground cellars from being used for the illicit production of beer. Many brewers took part in such activities and were subsequently charged with violation of federal laws. In later years, the main part of the wall was removed to allow passage inside, although a portion has been left behind.

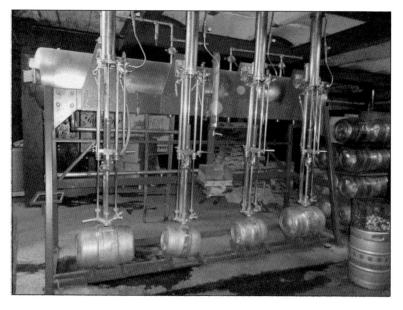

Also in the brewery's basement is the original equipment used in the racking process, or the filling of barrels. In the past, it was a high-maintenance process, requiring a great deal of manual labor. Today, much of the process has been mechanized and streamlined for efficiency.

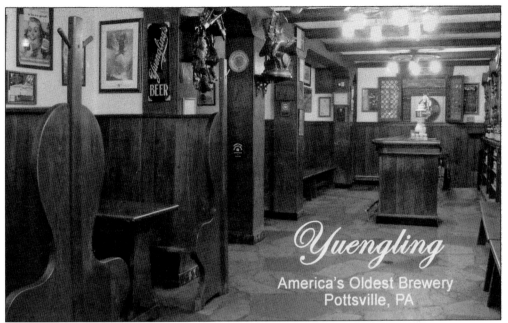

Yuengling
America's Oldest Brewery
Pottsville, PA

The final stop on the brewery tour is the rathskeller, shown above in a postcard view. This is a small hospitality room featuring a large wooden bar, shown below, where Yuengling Beer is served, fresh from the brewing process. The walls are covered with historic photographs and other memorabilia. The rathskeller was built for brewery visitors soon after Prohibition's repeal in 1933. The window on the far wall is frequently open during the summer, showing the brick wall of St. Patrick's Catholic Church, just inches away.

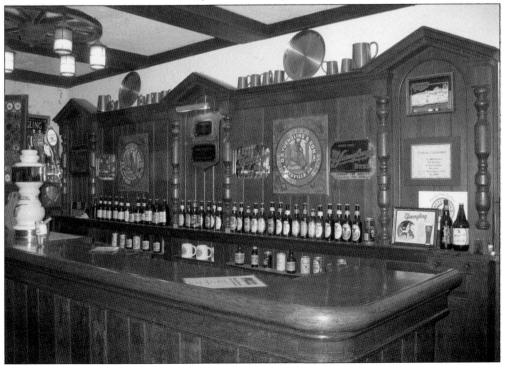

The large Yuengling gift shop, shown above, also houses much of the company's extensive museum of historic advertising, photographs, packaging, and other memorabilia relating to its long history of brewing. Part of the collection includes an assortment of 19th-century bottles shown below. The room is housed within the brewery and is directly beneath large tanks that hold grain for the brewing process. These are clearly visible in the ceiling, and one can often hear the sound of grain moving through pipes toward the brewing area. (Below, courtesy of D.G. Yuengling & Son, Inc.)

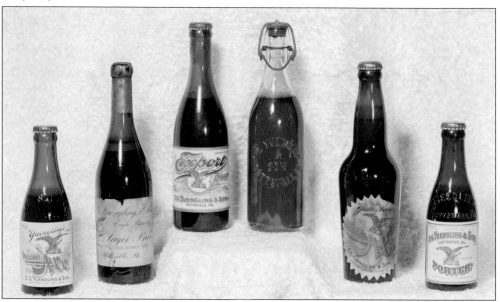

Seven

AMERICA'S
NEWEST BREWERY

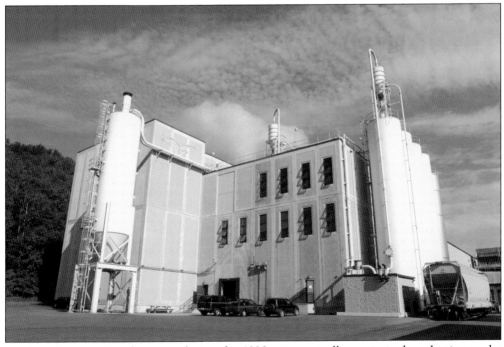

As Yuengling continued to grow during the 1990s, it eventually maximized production at the original brewery. Being land-locked, however, that plant was not a candidate for a large-scale expansion. Further growth of the company thus depended on the construction of a new brewing facility altogether. In 2001, this new facility opened at 310 Mill Creek Avenue in the Port Carbon area, two miles east of the original plant. When first opened, it was known as "America's Newest Brewery." (Courtesy of D.G. Yuengling & Son, Inc.)

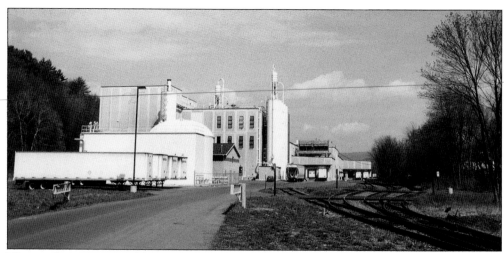

The new brewery covered 300,000 square feet, employed 100 additional workers, and added 1.2-million barrels of annual capacity to the company. During its first year of operation, it operated well below capacity until a new rail line (shown here) was built to the plant, allowing easier delivery of grain for brewing and allowing the plant to operate at full capacity. (Courtesy of D.G. Yuengling & Son, Inc.)

how yuengling beer is brewed

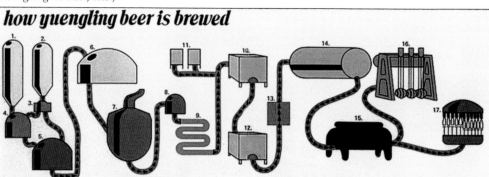

The brewing cycle begins when the proper amount of corn grits (1) and malted barley (2) are removed from the storage bins. The malted barley is put through a mill (3) and crushed to a desirable size. The corn grits and a portion of the malted barley with Yuengling pure mountain spring water are then added to the grits cooker (4) where the grits are softened and liquified. During this cycle the balance of the crushed malt is added to Yuengling's spring water in the mash tub (5). The cooker mash is then added to the mash tub where the mashing cycle is completed. The mixture is pumped into the lauter tub (6) where the extract is removed from the grain. The extract is known as wort. The wort is pumped into the brewing kettle (7) where it is boiled and hops are added for aroma and flavor. After the boiling cycle is completed in the kettle the hops are removed.

The brew is then pumped into the hot wort tank (8). From there it is pumped through a cooler (9) and into fermenting tanks (10) where pure brewers yeast is added from the yeast tanks (11). The fermentation cycle is completed in about a week after which the beer is pumped into storage or aging tanks (12) where it remains approximately 10-14 days. The next step is filtration (13) to achieve sparkling clarity. At this point the carbon dioxide is adjusted to the proper level to insure extra good taste and foaming qualities. From here the beer is pumped into finishing tanks (14) and held for several days. During this time it is checked by our brewmasters for taste and quality. Then it is filtered a second time (15) before being put into kegs (16) or pumped to the bottling shop and put into bottles or cans (17).

Yuengling's brewery experience is not just about the history; it is also about the beer. The company's brewing process is outlined in this diagram and follows the same steps in all three of the company's breweries.

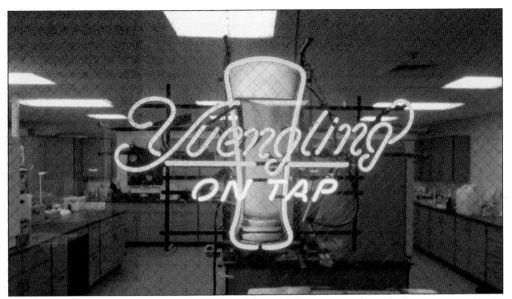

The Mill Creek brewery features a large state-of-the-art laboratory to allow the brewers to maintain a scientific approach to the brewing process, evaluating each batch to make sure it is consistent with Yuengling's standards. This view through the window of the laboratory also shows a prototype neon sign for the brand.

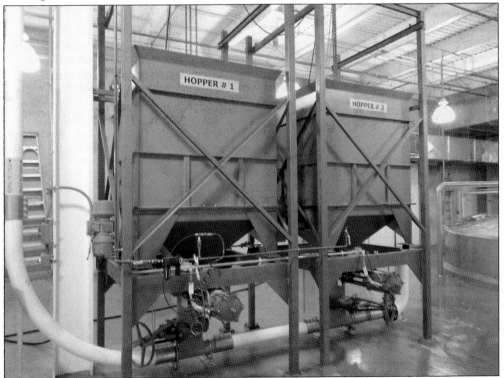

At the beginning of the brewing process is the grinding of malted barley in the Mill Creek plant's malt mill, shown here. After this step, water is added along with corn grits, as the cooking process begins to take place.

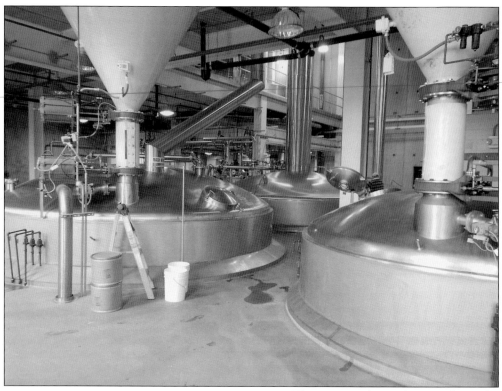

The interior of Yuengling's Mill Creek brewery is strikingly different than that of the original plant, being far larger and more spacious in addition to its new appearance. This view shows the mash tub, where an early phase of the brewing process takes place, in which malted barley, cooked corn grits, and spring water are mixed.

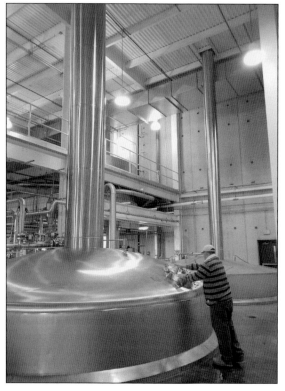

This view shows the brew kettle, where the liquid extract from the cooked malt and corn, also known as wort, is boiled along with hops, which are added for flavoring. This kettle is larger than that of the original brewery and can hold up to 650 barrels at a time.

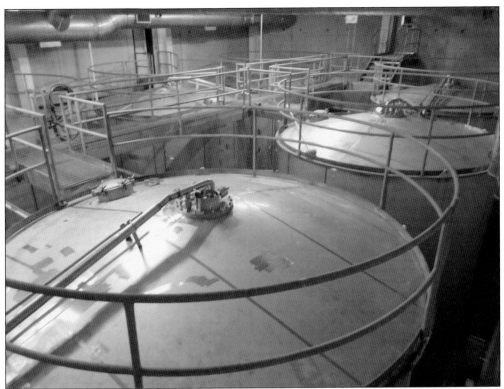

The huge room seen here in two views contains multiple fermenting tanks, where yeast is added to the boiled wort and the mixture becomes beer. These huge tanks are 70 feet in height, and each contains just over 2,000 barrels of beer. During the plant enlargement of 2010, multiple new fermenting tanks were added, and these were the tanks that would allow the brand to be sold in Ohio for the first time during the following year.

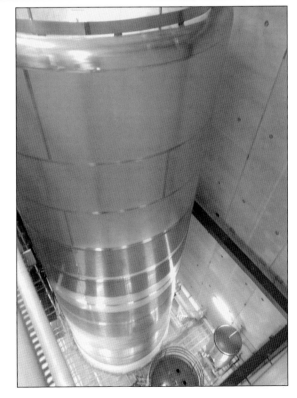

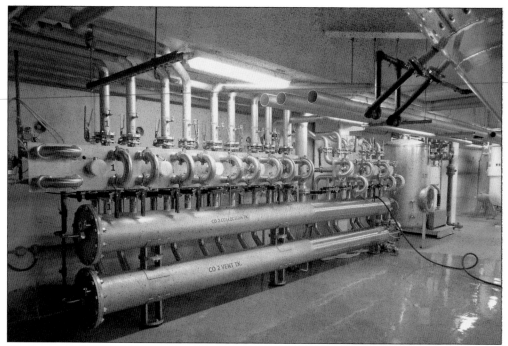

On the ground level is an extensive system for the collection of carbon dioxide gas, a by-product of the fermentation process. This gas is collected and then reused to add carbonation, or fizz, to the beer prior to being packaged.

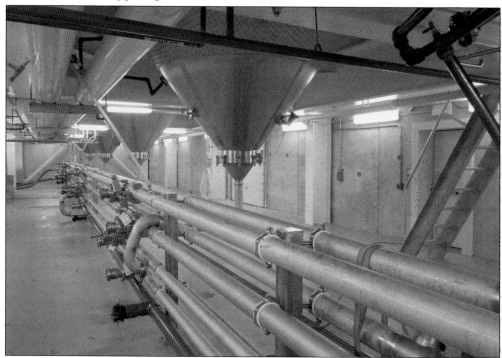

The brewery's interior contains miles and miles of pipes for transporting thousands of barrels of fluid through the brewing process every day. These pipes even continue on the roof of the plant.

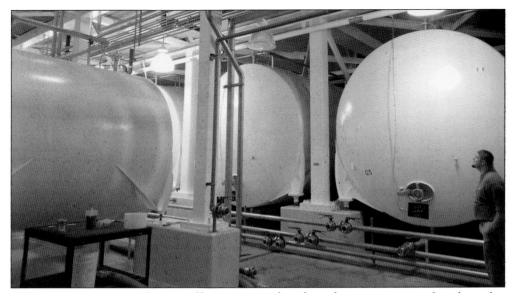

This room contains row after row of huge aging tanks, where the aging process takes place after fermentation has been completed. First developed in the 1840s, this aging process is what makes lager beer different from other beers. The particular taste of lager beer has made it the dominant style of beer in the United States over the past 150 years and has been responsible for Yuengling's tremendous increase in popularity since its lager was introduced in 1987. The lagering process requires that this room be kept at 38 degrees Fahrenheit. Looking on is Ryan Kehler, Yuengling's West Virginia district manager.

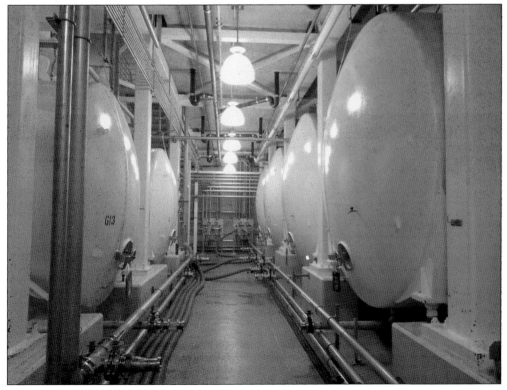

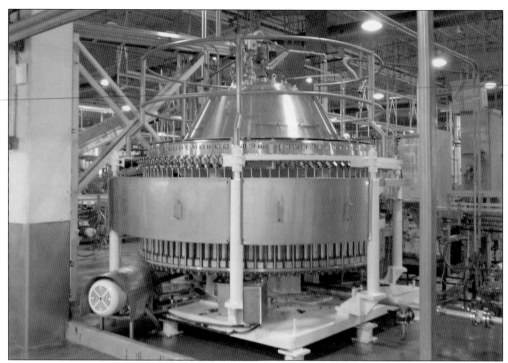

Above is the large bottle filler at the Mill Creek plant. After being filled, capped, and pasteurized, the bottles are packed into cartons and cases. Piles of these are then shrink-wrapped and stacked in the warehouse, as shown below. Pallet after pallet of piled cases of Yuengling Lager and the company's other brands fill the warehouse on a typical day before being shipped.

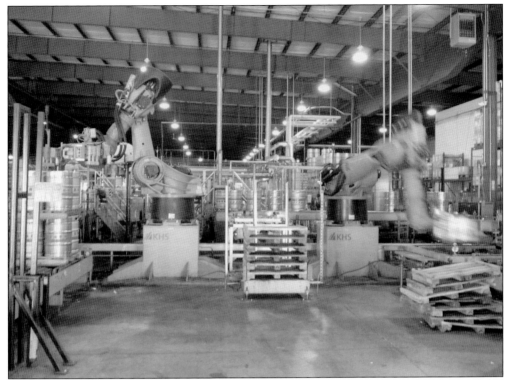

These two huge robotic arms stand inside the Mill Creek warehouse. Their job is to move full barrels of beer just prior to being shipped out. Much of the heavier labor that was once performed entirely by hand is now completely mechanized. The robot on the right was in motion when this photograph was taken, giving it a blurry image.

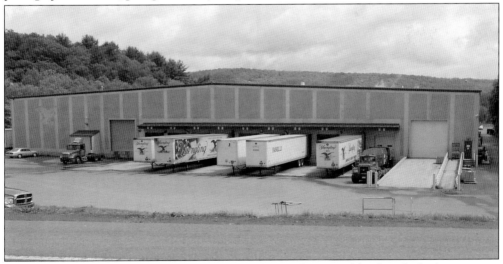

At the far north end of the Mill Creek plant is the warehouse and loading dock. At any given time, several large trucks are likely to be parked at the dock being loaded with beer that is headed for distant locations. At the time of its construction, the Mill Creek brewery had twice the annual capacity of the plant on Mahantongo Street, and its 2010 addition enlarged it even further. This warehouse is dramatically larger and busier than its counterpart at the original brewery.

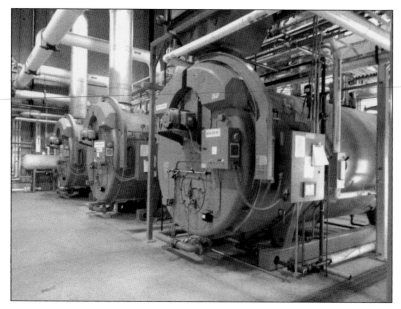

These three huge boilers provide power to the plant. Nearby, several air-conditioning units keep various parts of the plant at cool temperatures, which are critical to the beer's aging process. This extensive refrigeration process accounts for a major portion of the plant's electrical needs.

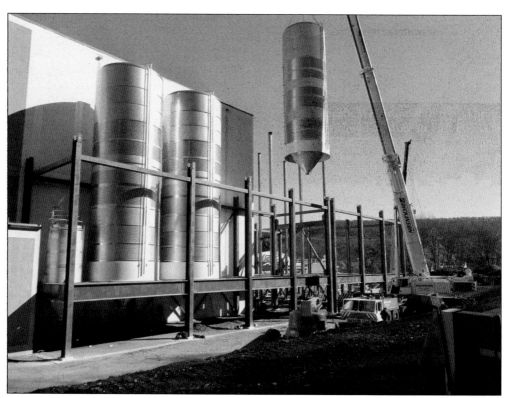

Continued growth in the demand for Yuengling beers necessitated an expansion of the Mill Creek plant in 2010 before it was even a decade old. This image shows huge new tanks, previously seen on page 111, being lifted into place during construction. A similar expansion of the Tampa plant took place after this. (Courtesy of D.G. Yuengling & Son, Inc.)

Eight

YUENGLING TODAY

By the early 1990s, Yuengling Lager, Light Lager, and Black & Tan had become the company's three biggest sellers and were responsible for the explosive growth that the company would see over the next two decades. Indeed, Yuengling's output of 127,000 barrels in 1989 had increased twentyfold by 2012 to 2.5 million barrels. This billboard, seen in 2011, shows the brand competing against national brands such as Coors. Twenty years earlier, this battle was consistently being won by the national brewers, but changing consumer tastes since that time had brought full-bodied beers like Yuengling Lager into the spotlight.

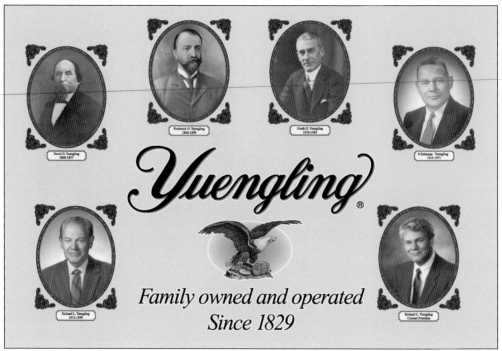

The Yuengling company remains acutely aware of its history and legacy and uses that factor to some extent in most of its advertising. Above is a promotional advertisement stressing the continuous family ownership of the company since 1829. Below is a horse-drawn wagon built in the 1990s to simulate an original 19th-century wagon, and it is used for various promotions. (Both, courtesy of D.G. Yuengling & Son, Inc.)

By 1999, the demand for Yuengling Beer had extended all along the East Coast and into Florida. In that year, the company purchased a brewery (shown above) in Tampa that had been built by the Schlitz Brewing Company in 1959 and operated more recently by the Stroh Brewery Company. Adding 1.6 million barrels to the company's annual capacity, it allowed Yuengling products to enter the market on a widespread basis in Florida, Georgia, and the Carolinas. Tropical-themed neon signs, some geared to the Hispanic community as shown below, began to appear throughout the region.

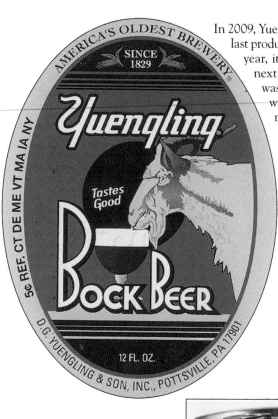

In 2009, Yuengling brought back its brand of bock beer, last produced in the 1970s. Only on draft in that first year, it became available in bottles starting the next year. The design of its label, shown here, was taken from a Yuengling Bock Beer poster with similar graphics from around 1940. Like most traditional bock beers, it is available only for a limited time in the spring.

By 2011, Yuengling products were available in 12-, 22-, and 32-ounce bottles as well as in 12- and 16-ounce cans. Yuengling Lager and Light Lager were also available in the large 24-ounce cans shown here. (Courtesy of D.G. Yuengling & Son, Inc.)

Lord Chesterfield Ale remains in production today, as it has since the end of Prohibition. Yuengling's only brand of ale, it is named after Philip Stanhope, who was England's Fourth Earl of Chesterfield in the mid-1700s. At right is a cardboard sign for the brand, utilizing the lady's portrait that was first used by Yuengling in the 1940s. Below is a neon sign for the brand.

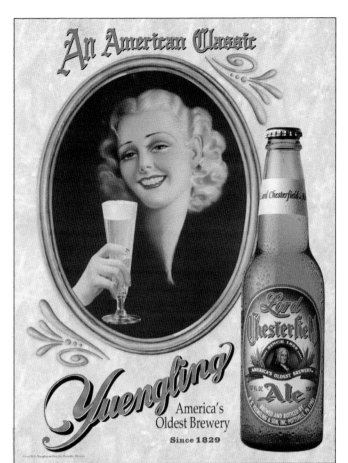

Yuengling's original water source for brewing was a hillside spring several blocks west of the brewery. The company owned the land around the springhouse and created a public park there in the late 1800s. By the 1960s, however, the plant's water needs had exceeded the spring's capacity, and the company began using filtered city water instead. For many years, the park was abandoned and overgrown, but in 2002, the company donated the land to the city for redevelopment. It was renamed Yuengling Bicentennial Park, seen above in 2010, with much of its 19th-century charm returning. Below is the renovated springhouse with water still flowing inside.

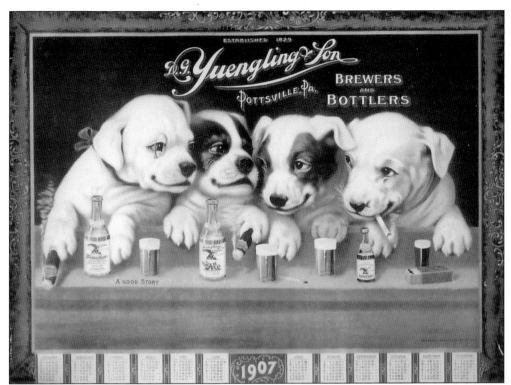

In recent years, Yuengling has reproduced some of its century-old lithographs in the form of advertising posters as another nod to the company's long history. Above is a 1907 calendar reproduction, showing four dogs that have appeared in several of the company's other modern advertisements. At right is a 1908 calendar reproduction, using a very different equestrian theme.

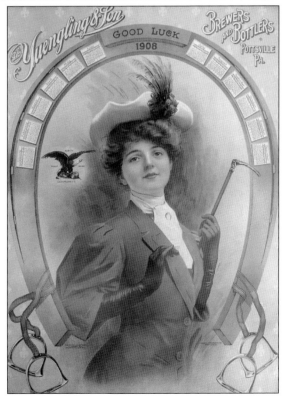

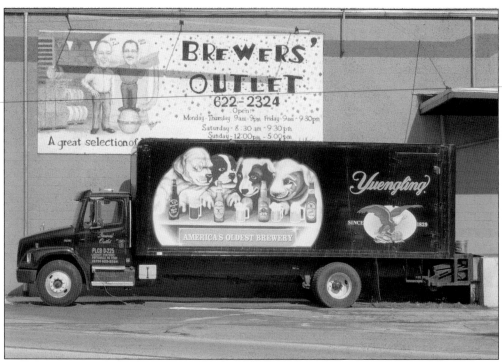

This delivery truck utilizes the four dogs seen on the previous page and is parked by the Brewers' Outlet, a Pottsville beer distributorship just a few blocks from the brewery.

This is another modern poster that reproduces an earlier advertisement. In this case, it is an advertisement for Yuengling Porter, the original of which appeared in the late 1930s.

Yuengling officially entered the West Virginia market in 2010 and immediately enjoyed great success there. This billboard, seen in New Martinsville along the Ohio River, showed that the company was ready to go head to head with Anheuser-Busch, the nation's largest brewer, and its flagship Budweiser and Bud Light brands.

Yuengling entered the Ohio market in 2011, an event which was celebrated throughout the Buckeye State. Ohio-shaped neon signs with buckeye leaves began to appear throughout the state as the company quickly achieved impressive sales there. This sign was seen in the window of a convenience store in Middleburg Heights, a suburb of Cleveland, in 2013.

125

The sixth generation of the Yuengling family is already involved in the brewery's management. Dick Yuengling has four daughters, and all of them have worked at the company in different capacities. Their collective experience in administration, marketing, and the brewing process itself assures that the company will continue to operate in the same traditional fashion as in the past. Above, from left to right, Sheryl Yuengling, Deborah Ferhat, Jennifer Yuengling, and Wendy Yuengling Baker pose with their father. Below, the four sisters pose near the bottling line. (Both, courtesy of D.G. Yuengling & Son, Inc.)